How to Draw without Talent

YES, I'M talking to you!

Danny Gregory

NORTH LIGHT BOOKS

How to Draw Without Talent. Copyright © 2019 by Danny Gregory.
Manufactured in U.S.A. All rights reserved. No part of this book may be
reproduced in any form or by any electronic or mechanical means including
information storage and retrieval systems without permission in writing
from the publisher, except by a reviewer who may quote brief passages in
a review. Published by North Light Books, an imprint of Penguin Random
House LLC.

penguinrandomhouse.com

3 5 7 9 10 8 6 4 2

ISBN 13: 978-1-4403-0059-2

Edited by Noel Rivera
Designed by Clare Finney and Danny Gregory

For the students of
SKETCHBOOK SKOOL
xx Danny

Living the dream.

Why do you want to start drawing?

Wait, let me rephrase that—you probably don't want to *start* drawing.

You want to be really good at drawing.

You want to pick up a pen, grab some paper and effortlessly draw anything—perfectly, beautifully—dazzling your friends and confounding your enemies. You want to be the next da Vinci; to knock out portraits indistinguishable from photographs; to replace your vacation snapshots with breathtaking watercolors; to have gallerists, collectors and reviewers clamoring outside the doors of your sun-swept Tuscan studio.

Or maybe you have pictures floating in your head that you'd like to get down on paper, perhaps to illustrate a story or convey an idea.

Or perhaps you have a more practical goal in mind—you'd like to make products to sell in an online store or illustrate the menu in your restaurant or quit your job and live off drawing caricatures of tourists in the park. I have a friend who learned to draw just to save money on creating icons for an app she was developing. Her practical goal soon led her to a deep love of drawing for its own sake.

Whatever your reasons for wanting to learn how to draw, you can. I promise. I've taught loads of people who considered themselves hopeless at sketching, and I've figured out ways to make it fun and give them quick and satisfying results. Drawing is not brain surgery (though I have taught a number of brain surgeons and a couple of rocket scientists, too).

Before we start to draw, I'd like you to think about why you want to learn. How do you imagine drawing will fit into your life? What would you consider success? What would a perfect day be like when you can draw? What sorts of things will you love to draw? What will happen when you do? I urge you to write these thoughts down some place where you can refer back to them.

Let me tell you why I think this is important.

Learning to draw is fun and natural, but it takes a bit of work to achieve the level you'd probably like to reach. It's not unpleasant work, but at times it can be challenging. And when you encounter the types of challenges that are an inevitable

part of stretching and growing, a voice in your head may pipe up and suggest you chuck the whole thing and binge watch something on Netflix instead. That voice will tell you that this whole enterprise is a waste of time, that it has no practical purpose, that this book is terrible and that I have no idea what I'm talking about. And then it will pull out the big gun and tell you flatly that you have no talent.

That voice can be very persuasive. You may have heard it before when you tried learning to draw in the past. It may have convinced you to banish all sorts of other drawing-instruction books to a dusty fate on a tall bookshelf. But it's not going to work this time. No, sir. I'm onto the voice's tricks (in fact, I wrote an entire book about them called *Shut Your Monkey*), and I have prepared reinforcements to support you along the way.

The first one is that little essay you are about to write describing why you want to learn to draw, why it's a dream you've long held, what wonderful pleasures you know it will bring, what doors it will open, what adventures it will unfold. Write that essay with that little voice in mind. Make it strong and enthusiastic and forceful to beat back the objections you may face. Avoid excuses or stammering or second guessing. Describe your drawing dream and why you want it to come true.

And it will.

Now start writing.

"Before" drawings.

Alright, that's enough chitchat. Let's make some drawings.

Yes. I know it's scary. But I want you to do a bunch of drawings before I teach you a thing.

It'll be a way of establishing a benchmark, something you can look back on when you've worked your way through this book.

But it's also worthwhile because it will show you that you can already do more than you think. Even though you may not feel you have any ability, the fact is you're still capable of doing *some* kind of drawing.

We'll do a few drawings just for us. You don't have to ever show them to another human being, ever.

Get out a couple sheets of paper. Grab a pen.

Spend two minutes drawing each of these subjects:

1. A mug

2. A car

3. A tree

4. A building

5. A person

First hand drawing.

And now let's try one more drawing—this time from observation.

 I want you to draw your hand. If you are right-handed, draw your left hand and vice versa. Simply lay your hand on the table next to your paper and draw it. Don't trace around your hand. Just draw it.

 Spend five minutes doing that, then put it aside with your other drawings.

 How did that feel? You just spent a total of fifteen minutes drawing. Was it surprising? Stressful? Disappointing? Eye-opening? Write down your immediate reaction. It'll be very interesting to look back on these early impressions once you become an awesome drawing machine.

Got talent?

We like to think that artists are people who are very talented. Much more talented than we are. And the reason we can't make art is because we weren't lucky enough to be born with that gift. We lost the cosmic lottery. There's just nothing we can do about it. We are destined to be envious bystanders.

The good news: That's hogwash.

The fact is, drawing is just a skill. It's like a lot of other skills you were taught, probably at a young age, like tying your shoes, riding a bike and driving a car.

You never said to yourself, "I can't drive because I have no talent for driving." No, you learned some fundamentals, paid attention, got your learner's permit and got on the road. And for years and years, you continued to drive, boil an egg, read a book, operate a computer and use the many other skills you've learned.

Drawing is like that. It's not magic. And it's actually not that hard. In fact, I think it's not nearly as hard as learning to drive a car. A couple of years ago, my son started taking driving lessons and, in a few weeks, he went from being completely terrified to being confident—a driver. In fact, he

was able to move from being a pedestrian in New York to being a commuter in Los Angeles. Now that's driving.

You can do the same with drawing, probably even faster than my son took to drive cross-country (with just one fender bender!).

That's what I'd like us to do together in this book. I'd like to show you some very simple concepts that are the basics of what you need for drawing. And then we're going to do a lot of drawing together.

The number one drawing tool we need is something that's already inside of you. And it's not talent. It's confidence—a belief that you can. It may be be buried deep inside because you're afraid that you are hopeless at drawing, but we'll bring it out and do some exercises to make you feel more in charge and help you trust your abilities so you can make progress on the road ahead.

Let's get ready to draw—without talent.

Oh, and if you already have talent, well, here's a gold star; maybe you have a leg-up on the rest of us. But if you don't, it's okay. You have all you need: paper, a pen, a brain, an eyeball or two, and this book.

Skool with a K.

You may have noticed that on the cover of this book there's a logo for something called Sketchbook Skool. It's a funny spelling, but it's a serious business. For the last few years, my partner Koosje Koene (another funny name) and I have been running this online school, teaching people to draw, watercolor, make maps, do lettering and more. So far, we've helped more than 50,000 people make art a regular habit.

One of the key ideas behind the way we teach is that there's no one way to draw. There's no 100 percent correct, board-approved, state-sanctioned approach. In fact, there are as many ways to make art as there are artists.

And so our kourses (yes, another weird spelling) feature a different teacher every week. Their advice, their tools and their approaches all vary widely. Some may even contradict what you were told the week before.

It's all good because our goal is not to teach you to make art like any given artist—no matter how good—but to help you to make art like you. To find your own voice and style and technique. That's the most interesting, the most authentic, the best art there is.

I'm going to use that approach in this book, too. I'll teach you something, and then I'll bring in one of our fakulty artists to show you how they approach that concept. I've also asked them all (there are about fifty artists in our Skool now) to lob in other ideas, discoveries and assignments to make sure you get well-balanced servings of inspiration. It's going to make this book a vast, tasty smorgasbord. Grab a plate.

This page is why you bought this book.

When you're done reading it, you'll know exactly what drawing is and how to do it. And you'll be amazed how simple it is. By the ninth paragraph, you'll do your best drawing yet. And for the rest of this book, we'll start turning that knowledge into an actual drawing practice that will change your life and deliver everything you hoped for when you picked this book off the bestseller table at your local bookstore.

Ready? Here goes.

Much of drawing is a physical process. It's like swinging a golf club. Shooting a basket. Swimming a lap. Playing a Scott Joplin rag. It's a combination of perception and movement. Could you do any of those activities? Play the piano or tennis or sink a jumpshot? Maybe not today or tomorrow. But I bet you think that, with enough time and practice and concentration, you could sink a putt or ace a serve or play the banjo or juggle three balls or run a pool table reasonably well. You may not be Tiger Woods or LeBron James or Willie Mosconi, but you'd be able to do it well enough to really enjoy it if you put your mind to it.

Same deal with drawing.

Let's break down the process of drawing into its component parts: your eyes, your brain and your hand holding a pen.

First, your eyes, which see an awful lot more than your brain is willing to accept. Look around right now. It's overwhelming how much detail your eyes pick up. And overwhelming is certainly the word for it. Your brain is clobbered trying to process all that data. So, in response, it simplifies what it sees and boils it down into symbols. Your brain is an amazing computer, but it processes information in ways that are helpful for survival, which is not always ideal for drawing. You need to train your brain to stop turning what it sees into words and, instead, to deal with all of the shapes, lines, colors and tones it sees. We'll talk more about that later, but, for now, suffice it to say that we have to calm our brains down and get them to stop filtering everything we see.

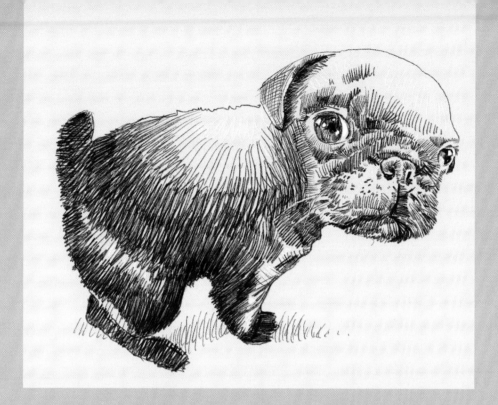

Then there's your hand. It can do a lot of incredibly specific and dextrous actions, but it needs to practice them to perform them automatically. I'll bet you can brush your teeth or tie your shoelace without even thinking or looking, but that's because you've done it thousands of times. Those actions are now hardwired into your system. You don't need to think consciously to walk or talk or drive or slice vegetables or knit a row or turn the pages of this book. Your body parts just know what to do. You already have very specific handwriting, a unique way of laying down ink on the page—again, automatically and without a lot of thinking. So there's no doubt that this same process could be used to lay down drawing lines just as easily.

In other words, you have a state-of-the-art printer and a wicked-fast computer. You just need to get them networked and install the software that will get them working together the way you want. It's not voodoo or a gift from the gods. It's just gonna take work, like doing a few zillion layups against the backboard in your driveway until you can sink a shot from anywhere on the court.

Back to your eyes. They are amazing devices, but you need to use them in a new way. Instead of scanning the horizon or flitting around the landscape, slow down and sharpen your focus. You're a predator by nature, so this should be easy. Just think of a cat stalking a sparrow on the windowsill. Hunker down, lock your eyes on your subject and move in slow

motion. Inch your eye along the edges of your subject. Notice every single micron. Glide up a curve, around an angle, along an edge. Smoothly, consciously.

Try it right now. Find some object in the room. Slide your eyes super slowly along the lower left-most edge until you get to the back of the object, then go up the side, curving around every ridge and bump. Keep going, sliding across the top, then down the right side and finally driving back to the starting point. Try your best to maintain the same speed, even if you are traveling along an unbroken line or slaloming through a complex set of curves.

Hopefully you didn't rush, and that trip took you a few minutes. Ta-da! That was the hardest part of drawing. Paying close attention and moving your eyes at the same pace is the most critical skill you need to draw anything. If you can look this way, you are most of the way home.

The next part is already fairly automatic. Because, if you make that super-slow and accurate trip with your eyes while holding a pen, your hand will record that path on paper of its own accord. It's amazing. It just knows how. It may not be 100 percent perfect the first or the tenth time, but it'll be pretty doggone close. Astonishingly so.

Try it again. Just clamp your eyes on that same object and super slowly cruise around the edges while resting a pen on a piece of paper in front of you. You don't even need to look down at the paper. Your hand will just go right along with your eyes. It's pretty awesome.

This is the same mechanism that lets you aim a bow or throw a ball, a complex set of calculations that your brain does on the fly and that your muscles, tendons and nerves carry out as commanded.

Is that "talent?" Call it what you will, but it comes preinstalled with every human brain, built right into the operating system, programmed over millions of years of being a tool-wielding primate predator. Thanks, great-great-grandpa.

And you can improve on that basic setup by slowing down further and practicing more, which is what the rest of this book is for. Because here's the secret: What I just explained to you is almost everything you need to achieve your drawing dream.

All we have left to do is convince the rest of your brain that I'm right by teaching you a few more lessons in slowing down, seeing more and thinking less. Just wait and see.

My story.

I don't think I have any real talent. I didn't go to art school. I've never really taken any art lessons. In fact, I barely drew at all until I was in my late 30s.

When I started, I didn't have much confidence. My drawings were shaky and lopsided. I honestly didn't know what I was doing. So I read a bunch of art instruction books. A lot of them were pretty complicated and mystifying, but I spent a lot of time looking at the drawings and looking at the work of artists I admired. I tried copying some of the drawings line by line. I tried tracing them. Then I decided it would be okay to go out and start making drawings. Bad drawings. Lots of bad drawings. Again, I was like my son driving around the parking lot, practicing his techniques. Trying time and again to parallel park. So I tried time and again to draw a tree, a bench, a person.

As I drew more and more, I overcame some of my anxiety and fear, and my lines got less shaky. It took me a long time to figure out how to see the thing I was drawing in such a way as to be able to copy it down on paper. I wasted a lot of that time fumbling around. But, eventually, I got there, and now I'm pretty confident that I can draw anything in the world.

People, buildings, animals, landscapes . . . you name it, I know how to draw it.

So now I want to tell you how, and I hope I've figured out how to do that. I've spent a lot of time trying to reverse engineer my drawing abilities; trying to figure out how to explain to other people what steps you need to take to develop some basic drawing skills. It's kind of like teaching my son to drive a car. I know how to drive intuitively at this point. It's in my bones. After years of practice, I have a similar attitude to drawing. I just know how to do it.

And soon you will, too.

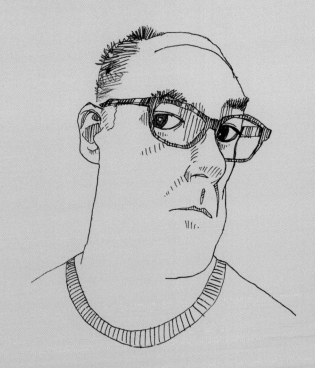

Pendamonium.

Let's talk quickly about art supplies. Bottom line: don't get crazy.

You can do these drawings in a basic sketchbook or on loose pieces of paper, even on plain 8" × 11" or A4 sheets pulled out of the copier or printer and stored in a folder. You don't need anything fancy or expensive.

I love gorgeous sketchbooks, but let's not use one for this leg of our journey. Let's use cheap, abundant paper we can afford to crumple up and toss aside. That will help us feel looser, less judged and freer.

I'm also going to ask you to use a pen for the exercises in this book. A simple ballpoint, a rollerball or even a narrow felt tip.

A pen.

What?! Why? Because it will make it easier.

I know that feels counterintuitive. You'd rather have an eraser at the end of a pencil.

But the fact is, there are three things you can do with mistakes:

1. Erase them and pretend they never happened.
2. Cry over them and beat yourself up.
3. Accept and learn from them. Mistakes are our teachers, and we are here to learn.

So, using a pen is a great way to remind us to slow down when we draw, because we know our lines are there forever. We are committed to them.

Drawing with a pen shouldn't make you super-hesitant, however. If you draw a line and it's not quite what you expected, that's alright. Wonkiness is okay. It has character. It's like a scar or a broken nose or a worn pair of jeans. If everything we drew were always perfect, well, we might as well just use tracing paper or a photo copier or a camera. Lines that are hard fought are lines with meaning. They communicate what we want through to make the drawing. And that's what makes them art.

Materials list.

- ☐ PAPER
- ☐ PEN
- ☐ time
- ☑ you

optional : Talent

Nice sketchbooks.

I find that the best way to desacralize the action of drawing is to not sweat the media. In fact, the more improvised the paper/the surface, the more likely I am to make something I like. The moment I grab an expensive sketchbook, the pressure to draw something nice is on. Pressure is the last thing we want here. You can't demystify with high expectations. A crappy surface like a placemat or the back of an envelope make for perfect pressure-relieving surfaces.

— France Belleville

Here there be dragons.

That's what it used to say on old maps to describe uncharted territory. So it's understandable that your blank page is scary, too, because it is infinite, immense and there is no map.

So let's start by putting down some rules. Rules as in ruler—straight lines that feel like roads and guides. They can help us to navigate. We don't have to stick to them 100 percent of the time, but it's reassuring to know they are there to give us perspective. They'll help carve infinity into chunks we can navigate.

Confidence is attractive.

A lot of people tell me, "I can't even draw a straight line." My first response is, "Then buy a ruler."

I can draw a straight line. There's no real trick do it.

You just draw very slowly.

Or you draw very quickly.

Watch this:

There's no trick to what I just did. In fact I didn't really think about it at all.

And now I'll do it again. But faster.

Now, what is the difference between those two lines? They're both pretty straight, but the first line is a little furry and shaky. The second line, however, is crisp and sharp. Now, the first line may actually be straighter than the second line, but I think the second line is what we mean by "I can draw a straight line." It looks confident, and it looks to me

like I drew it. It has my style. It has my hand behind it. It's like signing my name on a document. I do it with confidence. It looks like me. Like my signature. And this is where we want to get to with the lines we put into our drawings. You want to feel confident about them. Even if they're wonky. Fake it till you make it.

I've drawn a lot of straight lines and a lot of not-so-straight lines. Drawing lines is a pretty fundamental part of drawing many things, so I've done it quite a lot. That's the key. Practice. Practice makes perfect. And you don't need to be perfect. You can draw things that are off-kilter, and they can still be wonderful drawings, even if none of the lines are straight. They're just straight enough.

The thing to avoid is scratchy-scratchy.

This happens when you're not totally confident, so you try to approximate by drawing lots of overlapping lines. That just makes for a fuzzy drawing. It feels like you're stammering or stuttering instead of just spitting out what you mean in a clear, fluent, graceful line.

Why don't you give it a try now? Can you draw a straight line? I bet you can. If not, draw two, or ten. Try some slowly, others more quickly. Do some practicing. Feel confident.

Sketchbook intimidation.
Don't fear the first page in a new sketchbook. Start in the middle of the sketchbook instead. To get to know the behavior of your tools on the new sketchbook's paper, fill a page drawing with your favorite pens.

— Koosje Koene

Make your mark.

Drawing is description. Light signals pass through your eyes and turn into electrical signals in your brain, then into movements in your hands that become marks on the page.

These marks are a translation and a description of what you saw in your own visual "words." The particular words you use are personal and specific to you. They are your style, yes, but they are also created on an even less conscious level. Think of marks as your visual accent, your vocabulary, your way of expressing yourself.

Just as there are so many ways to sing a song, marks are your particular interpretation of experience.

There are an infinite number of ways to make marks, but there's a particular way that you make them. Next, we're going to bring out your individual way of making them.

We're also going to develop a vocabulary for representing the things we see and the feelings we have.

Marks can describe how the artist making them feels at that moment—thoughtful, scared, pleased or intrigued.

Marks can be a way of drawing a line. They can also be a pattern we create to represent light and shadow or texture or surface material. They can work pictorially to hold our compositions together and create a complete and integrated picture.

If this seems a little much—you just want to learn to draw, after all—don't worry. After a few simple exercises, you'll see why making marks is so important and so much fun.

Let's start by doodling. Nothing scary in that.

Different strokes.

Grab your pen and try to make as many different kinds of marks as you can.

Spend five minutes just filling the page with as much variety as possible. Push yourself to create new types of marks.

You are creating your own visual vocabulary. Approach it like you did when you were three or four, scribbling with a crayon.

When you're done, review the marks you made. Can you see any consistencies? Are there categories of marks? Are there any particular marks you really like? Do any remind you of something else? Do they look like tree bark or roof tiles or cat fur? Maybe you can use them in some future drawing. Hold on to this page. It may be the Rosetta stone that art historians look back upon when they work on the coffee table monographs of your career.

Marks to music.

Music is such a great conductor of emotion. It can make us cry or dance or chill out. Let's see how music can effect the lines and marks we make.

 Pick four really different recordings. Different genres, different tempos. Some you love, maybe some you don't. The idea is to pick tracks that make you feel different things.

 Now put on headphones so you can concentrate and let the music move your pen. Make marks that express what you're hearing and how you're feeling.

Gymnopédie No. 1
Erik Satie

Bltzkrieg Bop
Ramones

'Round Midnight
Thelonious Monk

HUMBLE.
Kendrick Lamar

Marks you can feel.

Marks can describe the way things look, but also the way they feel—rough or soft or bumpy. Marks can convey textures like leaves or fur or wood. Additional information that goes beyond the visual.

Pick any two objects that have very different textures. Something rough and something bumpy. Or something soft and something sharp.

Watch how Veronica Lawlor draws the surface of a hairbrush.

Notice how she uses her marks to capture the feeling of the different surfaces of the brush. She uses lines, circles and different types of squiggles to create a visual vocabulary that replicates what she sees.

She doesn't draw any outlines. She lets the marks convey the whole. As she draws, the shape of the object emerges. When the marks are closer together, the object seems denser. When there's more space between them, it feels fluffy and more open.

As you try this exercise, don't think about the object you're drawing. Don't say, "this doesn't look like a hairbrush" (or whatever your subject). Just focus on the surface and capture how it feels with the marks you make.

Look back at the marks you made earlier when you were doodling. Are there any that seem like the surface you're drawing now? Try them out here.

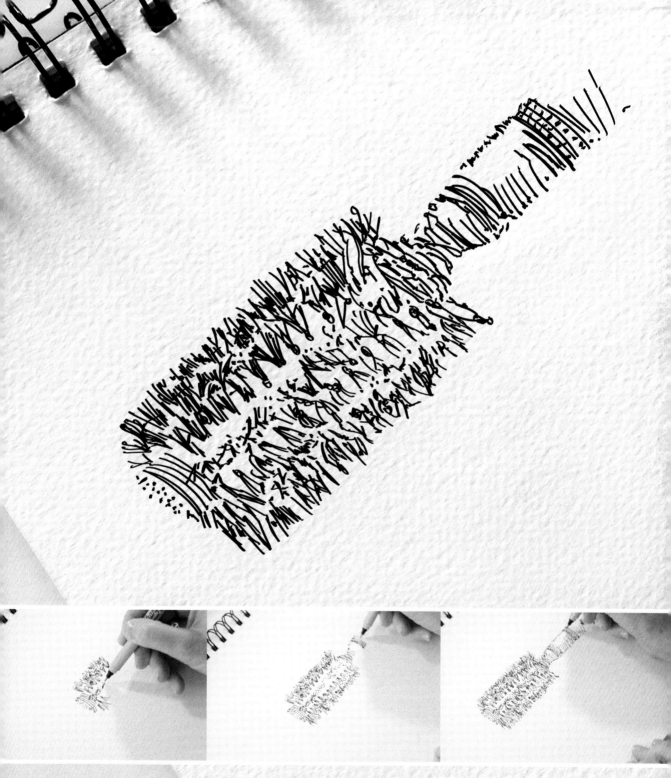

Tracing permitted.

When you were a kid, chances are someone told you that tracing was cheating. It's not.

Tracing can be an opportunity for building your confidence and creativity.

Many great artists use tracing to solve compositional problems or to combine existing images into brand-new ones.

Try tracing a photo, but simplify the image as you do. Reduce the image to a small number of clean lines. Because you know where to place your marks, you can make them confidently. That's what we want. Just practice making lines and decisions.

You don't need to copy just one photo. Make your own. Trace features from different people in magazines and create a new celebrity.

Or use a tracing to give you a leg up. Use it to help you identify reference points, then complete the drawing on your own however you want. Remember, you don't have to trace the entire image. Fill in some parts using your own imagination or style.

No tracing paper? You can turn an iPad into a lightbox. Turn on the flashlight app, then slip the tablet under your page and your reference picture. The light will make your paper transparent.

You can also use the light from a window. Tape your reference image to the glass and hold up your sketchbook, and your image will show through the paper.

Tracing can be creative! Add it to your toolkit.

Draw shapes.

What is a car? It's just a bunch of shapes. So is a face. So is a cathedral. So are shadows and reflections.

No matter how complex your subject, every drawing is basically a collection of shapes.

Those are your building blocks.

When you can see past the complexity and break your subject down into those blocks, you can draw anything.

27

The shape of shapes.

Some shapes are mechanical or technical or geometric. These shapes tend to have specific names.

Square Nonagon Oblong Orb Oval Cube
Rhombus Rectangle Trapezoid Circle
Heptagon Octagon Triangle Parallelogram Cone
Star Decahedron Crescent
Diamond

Then there are the vast majority of shapes we run into that have less accurate and elegant names.

Lump Chunk Glob Bean Bulge
Clump Hunk Blob Bump Nugget
Protuberance Doohickey

We'll call these organic shapes.

Most of the world, except for buildings and rulers and dinner plates, tend to be made of organic shapes. The fact that we don't have names for them is a problem we're going to tackle in a few pages.

Look around you right now and identify the shapes in your environment. Write down a list of 10–20 shapes and where you see them.

pan · stool · cake · face · tree · tower

How Freekhand keeps in shape.

Miguel Herranz got the nickname "Freekhand" when a friend watched him draw. His hands are magical and freaky.

Here's a little game he likes to play to warm them up.

Take three shapes: a circle, a straight line (any length or angle), and an organic closed shape.

Now, draw as many things as you can just using those three shapes.

Keep pushing yourself to come up with more.

Now try the game with three other shapes: an ellipse, a rectangle and a triangle.

How many things can you construct with just these three shapes? Now, come up with some more.

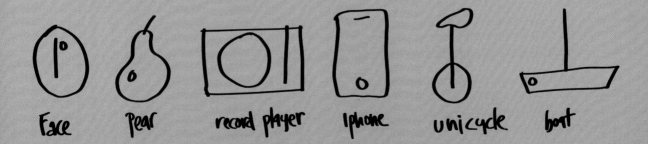

Face · Pear · record player · Iphone · unicycle · boat

The ABCs of drawing.

So far we've played with marks and we've talked about shapes. Now let's start working on the real process of how to draw—and that begins with seeing.

When we draw, we need to observe our subject in a different way than we do when just going about our normal day-to-day life. We need to look for the shapes that make up our subject, to break down what we see into component parts we can record on paper. We need to analyze and measure those parts, and we need to develop a way of turning the organic shapes we see into a shorthand that lets us communicate between our eyes and our hands. If our eyes see them but we cannot tell our hands what they are, the results will not be pretty.

How do we do that?

We start with our ABCs.

The modern English alphabet has twenty-six letters. You learned it when you were probably five years old. Those twenty-six letters let you read any words that anyone could ever put down on paper.

If you learned how to read music, you learned how to read the treble clef, to tell one note from another, and how to translate what was on the score to the keys of the piano or the strings of the violin. Again, learning the building blocks allows you to arrange them in an infinite number of ways.

Drawing has an alphabet, too. We need this alphabet to break down the complicated things we're looking at into their component shapes. We can then put them down on paper.

If you try to draw something and it just seems like an impenetrable jumble, well, that's understandable. It's a lot to take in. We wouldn't expect a first-time concert-goer to decode what every instrument in the orchestra is playing during a Beethoven symphony. It's like looking at a dense page of text in a foreign language when you've never studied it.

So let's learn the ABCs of drawing. The good news is that there are only five of them. Just five basic elements that allow you to draw anything on earth.

straight lines

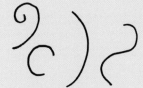

curves

angles

Here they are:

First, lines. There are three types of lines:

1. Straight
2. Curved
3. Angled

Next, shapes. There are two types:

1. Roundish ones are colored in; we'll call these dots.
2. Round shapes or outlines that are empty. We'll call these circles. (Though some of them are really ovals or footballs or amoebas or clover leafs or kidneys or eggplant parmigiana subs.)

What's useful about these five letters of the drawing alphabet is that we can use them as a way of talking ourselves through our exploration of the landscape we are drawing. Everything we see is going to be either a line, a curve, an angle, a dot or a circle. This is the alphabet we will use as we describe the world to ourselves.

Just like when we first learned to read, we're going to start by sounding out those elements, feeling our way through them in a very conscious manner, moving our lips as we draw. After a while they will become second nature, and we intuitively know what we are seeing and, therefore, how to put it on paper. We won't think about the alphabet so much. We'll draw with our experience and intuition.

By the way, I first learned this approach from a wonderful book by Mona Brookes called *Drawing with Children*. It's great for adults, too. Read it next.

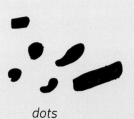

dots

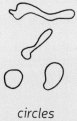

circles

Try out the ABCs.

Okay, let's put the alphabet to work.

Here are a few abstract designs for us to work with.

Let's start by "reading" them and then copying them down, element by element. Look for lines, curves, angles, dots and circles.

Draw a square on your page. Now copy all the elements in the first box one by one.

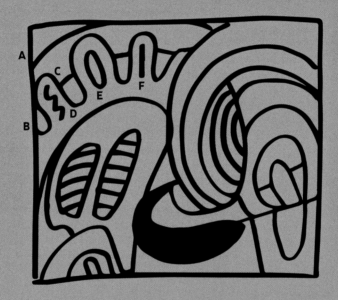

I'll start you off. Begin in the upper left-hand corner and work your way across and then down.

First we see a curved line (A) that cuts across the corner. How far does it go? Where does it intersect the box? What's the angle like?

Next down, we see another curve (B), a loop that goes from the left side of the box then hooks back. It's defining the first space between what looks sort of like three stubby Mickey Mouse fingers.

The next wavelike finger curve (C), goes down then curves up and then down, up, down, up until it hits the long, left-hand curve two-thirds of the way to the right.

Now let's fill them in. There's a curve (D)—almost a squiggle—that looks kind of like a 3 inside the first loop. Then an oval (E) that looks like a long O in the next one. And a straight line (F) in the final curve.

How do your shapes look? Are they taking up the right amount of room? Have you hogged the whole box just drawing that one corner? Are the pieces fitting together like a jigsaw puzzle?

Carry on through the rest of the shapes. Slowly break down shapes into the parts of the alphabet by measuring and observing intersections until you have the whole square filled.

Take your time and try your best to be accurate. Talk to yourself using the kind of language I use above. Use the alphabet (lines, curves, angles, dots and circles) but feel free to add Mickey Mouse fingers, rising suns, shoe soles, seashells, Nike swooshes—whatever comes to mind.

Draw your lines slowly and carefully. Don't make them fuzzy or hesitant. If they are slightly off, don't beat yourself up. We are just at the beginning of this journey, and I need you to stay happy and healthy as we plow ahead!

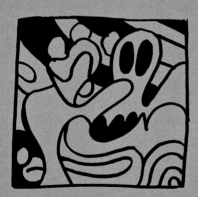

Awesome. That took a lot of thinking and observing, but I'm sure the five letters of the drawing alphabet helped you work your way through it.

You looked carefully, you measured angles, you made comparisons and you recorded each part of the landscape using lines, angles, curves, dots and circles.

Let's keep going. Copy as many different patterns as you'd like. Practice using the drawing alphabet to get every detail right. Feel free to talk to yourself while you do it.

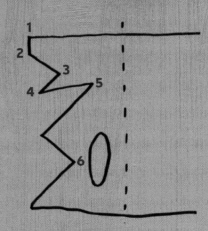

Mirror.

Now, let's get a little trickier.

We're going to continue drawing some abstract patterns, but this time we're going to draw what they would look like reflected in a mirror.

You don't need an actual mirror. We'll just use our brains to flip things. If a line in the original goes left, we're going to draw it right and so on. This will be sort of like patting your head and rubbing your tummy, but it will push us further in using the drawing alphabet to record what we see.

I'll walk you through the first one.

1. Start at the top and draw the first small line.
2. Turn at a 90 degree angle, but instead of going left, go right because you're drawing the mirror image.
3. Angle back 90 degrees with a shorter line than the last one.
4. Make a sharp turn to the left. Our line is twice as long as the last one.
5. Bank right with a very sharp angle—maybe 30 degrees—and draw the longest line so far.

And so on.

When you're done drawing the angles, add the circle, which is actually a tall oval. Its middle is halfway between the big angle (6) and the dotted line.

Challenging? Taxing? Fun for the whole family? Whatever it may be, do the next one all by yourself. (I call it the prune-faced dead man.)

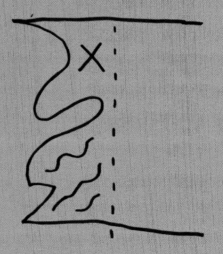

Wood you like to draw?

Let's look at the abstraction in a piece of wood.

Pick part of a wooden tabletop, a wooden floor, a cutting board or a tree stump. Make sure the grain is distinct.

Now, choose a section and copy down what you see using the alphabet. Record the smallest element you can see.

Keep increasing your magnification until you can't get any smaller.

Tenth time's the trick.

Wanna keep improving? Keep working. Practice each assignment several times. Maybe ten. And not necessarily all at one sitting. You will keep discovering new things and reinforcing the ideas you are learning. There's no hurry. Just have fun.

Be square. Be Leonardo.

Can you copy what's in this square into
a square on your paper?

How about what's in this square?

This one?

Now, could you copy what's in each of these squares?

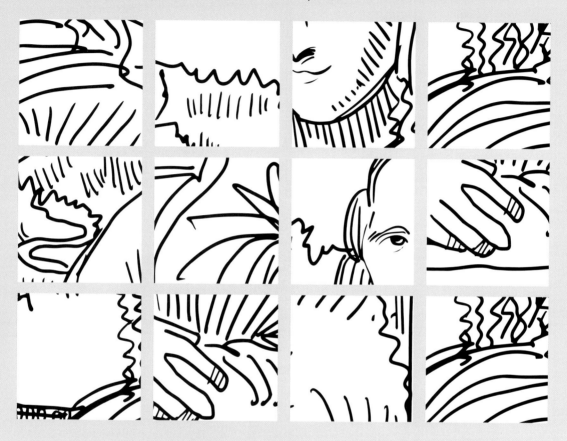

Congratulations! You just drew the Mona Lisa.

Gridding a reference picture can make it abstract. You will look at the shapes instead of thinking about what they make up.

This makes it easier to think in terms of the alphabet rather than "nose, eyes, hands, enigmatic smile."

To make it even more indecipherable, and therefore easier, try cutting up the gridded picture and picking squares at random. You could even turn them at different angles (don't forget to number your grid so you don't get lost!) and fill in your page like a jigsaw puzzle.

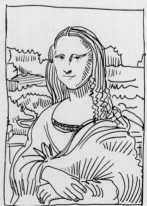

Let's get real.

It's time to get real. For our next exercise, let's move away from abstraction and draw some real things.

Yay!

Here's a bunch of drawn objects. We're going to copy the objects into squares on your own page, one by one.

We're going to continue using our drawing alphabet to copy what we see. At first you might be tempted to freak out because we're actually depicting reality (ack!), but take a deep breath and approach it like the abstract patterns we just worked on.

Here goes. Remember your alphabet. Think about where things intersect. Take your time. Draw confident lines.

39

Thinking upside down.

Why is it easier to draw something abstract than a real thing? Because our brains get in the way.

 Our eyeballs are bombarded with data all day long, like neck-top computers plugged into the biggest, fastest Internet connection ever. To deal with all that input, our brains have figured out how to process this information by breaking it down into categories with labels.

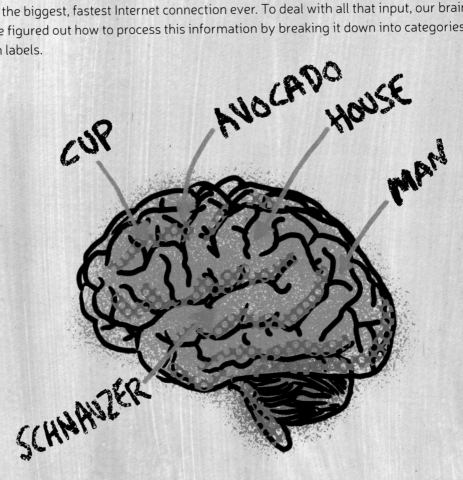

So instead of saying, "Look there's a wooden stick thing covered with bark that's about 45 feet high and has 84 branches and 7,612 leaves in fourteen shades of green and is lit from the left at a 40 degree angle . . ." we say, "There's a tree."

We look at a bunch of oaks and elms and birches and say "tree, tree, tree." Then we lump all of that information into one thing—a forest.

Sure, putting things into pigeonholes saves time for our brains, but it doesn't help us when we want to draw. We have an image in our heads of what a tree looks like (or a house or a chair), but those images are usually pretty rough and inaccurate. They're also generic. So when we go to draw an actual, specific tree, the picture in our brain tries to override it. It's as if we wanted to draw a rich, complex photo and ended up with a little crooked icon instead.

We have to route around this data management system by tricking our brains. Because we want to figure out how to process information—without using those rough, crude labels. It's easier when we draw abstract things because we don't have labels for abstractions. So we can allow our-selves to slow down and just record what we see.

But when we look at the parts of a face, for instance, our brain imme-diately says, "Oh, that's an ear. I have a shorthand label for that. That's an eye. That's a nose." And when you put that collage of rough things down on paper, it doesn't really look like the face we are observing at all.

What to do? Instead of saying, "Aha, a mouth," we have to break it all down with the drawing alphabet. That's most challenging to us when it comes to faces because our brains have a very complex way of processing facial information.

Here we're going to turn this system on its head by copying this drawing. But we're going to draw it . . . upside down. We can still tell it's a face, but it starts to look a lot more abstract to our information processors.

When we draw upside down, we can rely on our alphabet instead of our labels. If our brain tries to say, "Let's draw the eyes," replace that thought with, "That's an angle, that's a dot, that blob is round on the bottom . . . " and so on. It's just like copying the abstractions.

We are going to work our way across the drawing we are copying, from left to right, top to bottom. Look at angles, look at the lengths of lines, look at where things cross each other and where they run parallel. Break it all down into component parts that have no names, except line, angle, curve, circle, shape, and so on.

Think of it in little stages, like doing a crossword or a jigsaw puzzle.

And don't turn it right side up. Not until you are completely done with every part of the drawing. It'll be tempting, but don't, or you'll get your brain's labeling system back online again. Be patient and keep working across and down.

Then turn it around.

Pretty amazing, right? You did that. And you did it upside down!

Oh, one last thing. If you'd like to learn more about how your brain works when you draw, I strongly recommend *Drawing on the Right Side of the Brain* by Betty Edwards You'll find this exercise inside it and many others that will really open your eyes.

I talk about this system a lot in two of my other books, *Art Before Breakfast* and *The Creative License*. You might like them, too.

No time to go to the bookstore now, though. Get to work copying this image—upside down!

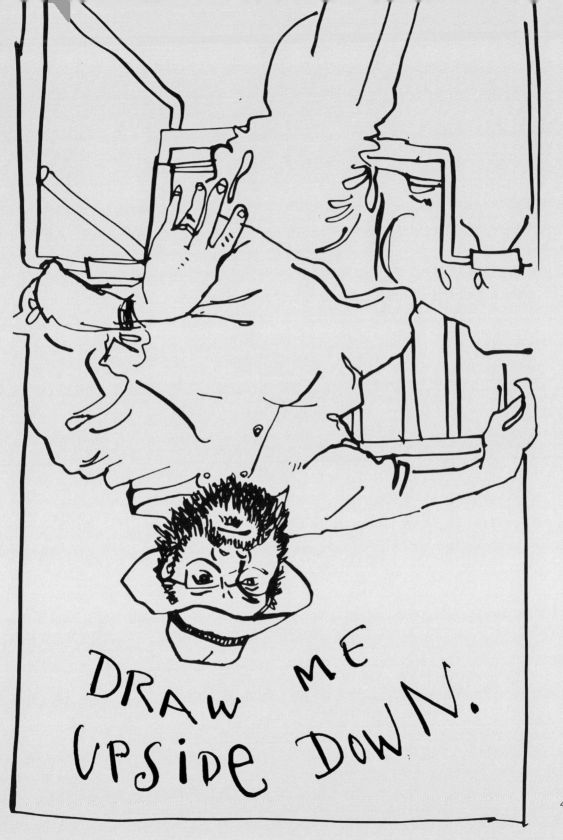

DRAW ME UPSIDE DOWN.

Memory bike.

Next, we're going to go from copying drawings to drawing what we see.

 Real things. New things. Yay!

But first, let's do another benchmark: a drawing from our memories. Let's take something simple that you've probably seen thousands of times in your life. A bicycle.

 It's a pretty simple object. Two wheels. A frame. Some other bits. Try to draw one right now. From memory. Don't worry about what the quality of the drawing is. You can throw it away as soon as this lesson is done. Just try to remember as much as you can about what a bicycle looks like.

 Go ahead.

How to see.

That was interesting, wasn't it? It was probably pretty frustrating, too. Because even though you know what a bicycle looks like, there are actually 1,000 questions that come up when you sit down to draw.

Where do the pedals go? Where does the chain go? You did remember the chain, right? What about the saddle? Where did you place it? Where do the handlebars connect to the bicycle? Did you remember to draw the brakes? Did you have any idea how many spokes there were on each wheel?

There are so many details on a simple device like a bicycle that we misconstrue. And it's this tendency that we have to overlook details, to make assumptions about what we think we see, to rely on memories and half-baked inventions that live in our brain that is the biggest stumbling block to being able to draw.

What we need to do is slow down. Concentrate. And observe in detail. We need to see what is actually there in front of us. And only then can we transfer it onto paper. The problem is not the pen we are using or the talent we have or don't have. It is a simple matter of knowing how to see. Knowing how to look at what is in front of us and how to make observations that we can then transfer onto the paper.

In a way, drawing is like taking notes. Our eyes say here's the first detail, and our hands put it down on paper. Our eyes say here is the next detail, and our hands put it down on paper. Detail by detail, our hands take dictation from our eyes and make a record of what we see. But if our brains are unreliable, refuse to pay attention, don't report every detail, insist on making up what's in the gaps rather than observing, that lack of attention will show up in what our hands put down on paper.

It's not magic. It's simply slowing down and paying attention.

Blind contour.

Let's start driving. We're going to drive around an object using a pen as our Ferrari. This is what we call a contour drawing.

"Contour" because we are drawing the edges we see. We're not concerned with textures or shadows, just the outlines.

I'm gonna draw my shoe. Now, I want to make sure I really focus hard on what I'm drawing and that I'm not distracted by labels and symbols and things. That I am seeing 100 percent.

So I'm going to draw while looking at my shoe the entire time. That's right, I won't look down at my paper once through this whole exercise.

We call this "blind" contour because I am blind to my paper and totally fixed on the subject.

Of course, this may well mean that our drawing isn't perfect, isn't 100 percent accurate. It may be an unholy mess. That's okay. I have the perfect excuse! I drew it blind!

So I am going to drive my eyeballs over every inch of this shoe. I am going to start on the upper left-hand corner and slowly drive along the top. As my eyes move, my hand follows along. It is doing its best to record the trip I am taking. And how do I do that? Veeeery slowly.

There you go. It looks sort of like a shoe, right? But most importantly, it looks like a journey. This drawing is a record of my journey. It's a map. A map may not look exactly like the landscape it is charting, but it contains huge amounts of information about the landscape it describes.

Blind contour is a terrific way to train your eyes to slow down, to not take anything for granted. While it's a great exercise for beginners, even professional artists do blind contour drawing on a regular basis as a way of keeping their eyeballs and brains in shape.

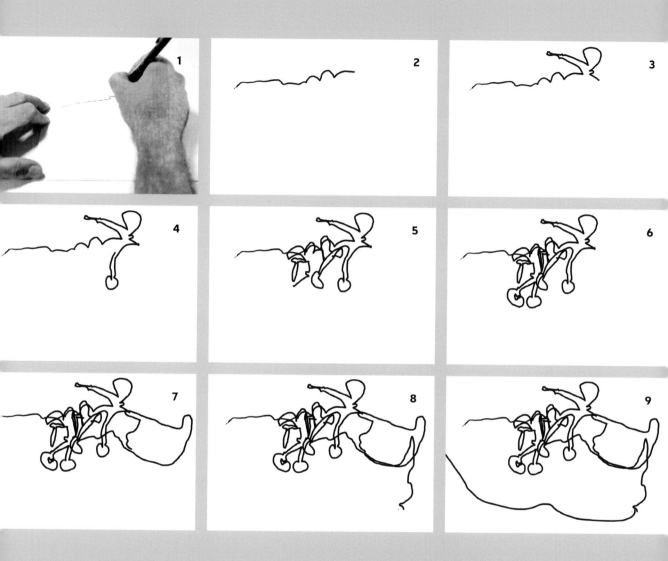

Try it. Take off your shoe, pick up your pen and open your eyes. No cheating. Go blind!

Check yourself before you wreck yourself: Are you speeding up?

Look down if you must reset to a different part of the picture. It's okay. I won't tell.

But when you're looking down to reposition, don't draw. Wait until your eyes are back on the subject.

Do this exercise for at least 15 minutes. Sloooooooowly.

What did you learn about your shoe while you drew?

Contour.

Okay, take off your blindfold. Next
we are going to try another contour
drawing, but we'll actually get to look
at our drawing as well as our subject
this time. Whew.

 Pick out an object in your house.
Something that's a little complex but
not overwhelming.

 I'm going to draw this bottle.

I start with my pen on the upper left-hand part of the paper (that's because I'm right
handed). I put my eyes on the upper left-hand part of the block, then I slowly drive along
the top.

 Remember our drawing alphabet. Figure out where you are encountering a line, a
curve or an angle.

 I want to do this as slowly as I can. I want to keep my speed constant—to stay on
cruise control. This is especially important because the block has several long, uninter-
rupted sections, so I have to really slow down to gauge how long they are. If I get bored, I
might speed up and then my drawing will get all cattywampus.

 I also look around as I drive my pen. Where does this turn correspond to something
on the other side? How steep is this angle compared to the last one I passed? I keep
asking myself these little course-correction questions.

 Notice how simple my line is. I'm not going scritchy-scratch back and forth over the
lines. I am making decisions and sticking with them.

 Give it a try. Pick a simple object and spend a few minutes drawing it on the page.

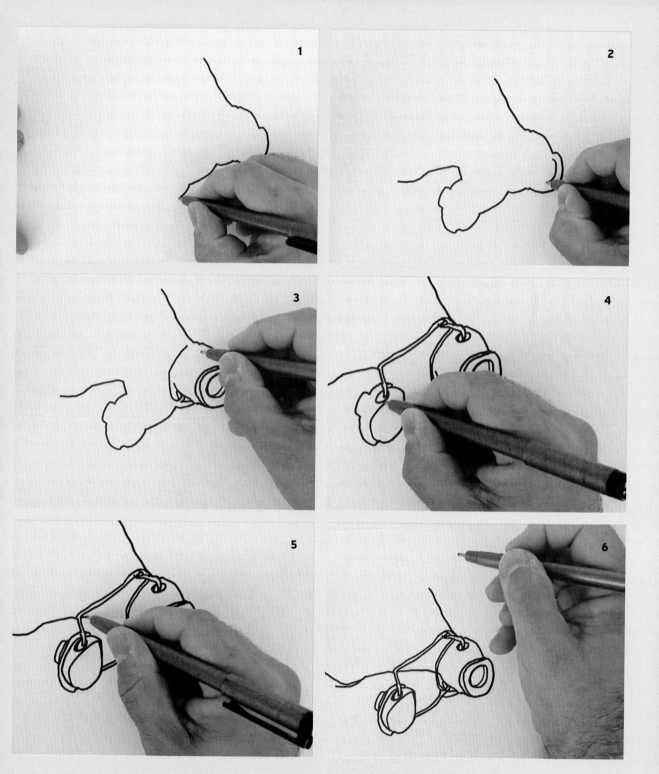

Landmark decisions.

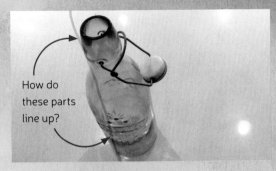

How do these parts line up?

One of the things you may be struggling with as you draw your still life is how to place things and how big to make things relative to each other.

How long is this line?

How wide is that angle?

Where does this part go?

How do these things line up?

The alphabet will help us figure out what the parts are but not necessarily their scale and relationship.

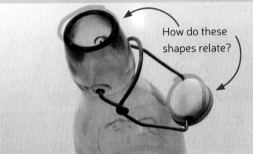

How do these shapes relate?

This is a time to think about landmarks. Landmarks break up the landscape. Turn left at the stop light. Turn right at the crossroad. Go a mile past the church. Go to the top of the hill.

How did you first figure out how to parallel park? Landmarks. You learned to back up until you could see the right front corner of the car behind you in the middle of the rear windshield. It took a while to absorb these landmarks, and

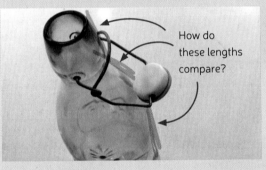

How do these lengths compare?

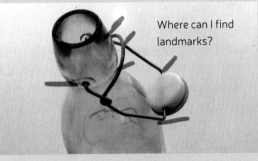

Where can I find landmarks?

even longer to make it second nature, but you did it and passed your road test.

We can do the same with drawing.

On the same page as your bottle drawing from the previous exercise, draw another view of the bottle on the same page and think about its landmarks as we go.

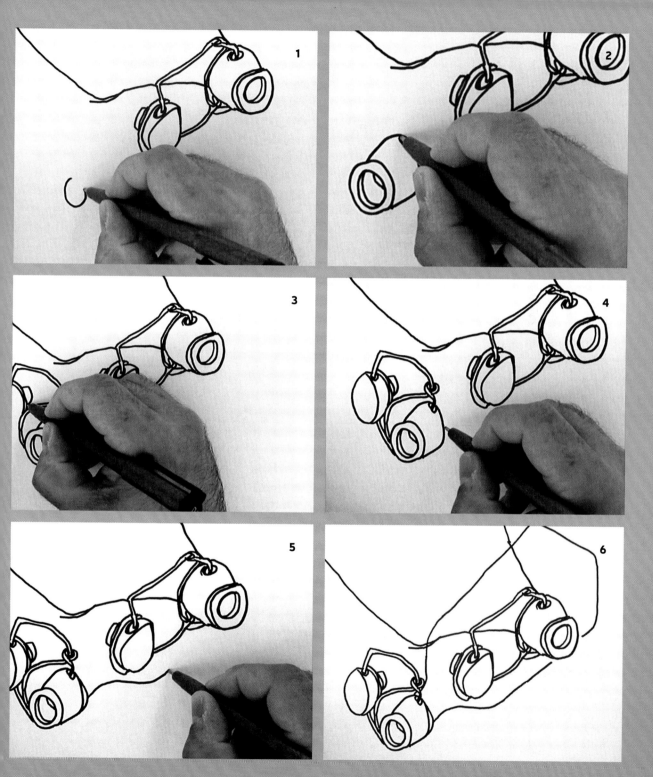

Drawing without drawing.

Recently, I had a mindful moment in an unlikely place. I had to go to a government office to renew a document. It was a large room filled with rows of chairs facing a series of steel desks with computers and clerks. Not Kafkaesque, just dead boring.

In my rush to make the appointment, I hadn't brought anything to while away the time—no book, no sketchbook. All I had with me was a sheaf of important documents.

A sign on the wall read: "No phones, cameras or recording devices." If I took out my phone to kill time, I'd be booted and have to make a new appointment for another time.

I shuffled over to an empty seat and slumped down, feeling like a snot-nosed, scuffed--kneed nine year old waiting to see the principal. Rows of people surrounded me, their faces blank, their eyes glazed. On the wall, a counter displayed a four-digit number in red letters. A number significantly lower than the one on the chit in my hand. I'd be there for a while.

I fidgeted a bit in my uncomfortable chair, then I squirmed, then I examined the boil on the neck of the man in the seat ahead of me, then I tried to calculate if the glowing number on the counter was prime. I hadn't had lunch yet, so I spent a while listening to my stomach, too.

Then I noticed a spray bottle of glass cleaner on one of the metal tables. I thought, that'd actually be interesting to draw. I liked the way the neck curved into the body, the six concentric rings that were debossed into the plastic, the soft highlight in the middle, and the way one square side of the nozzle was a slightly darker red than the next. I had a pen in my pocket to fill out forms but no sketch-book.

I decided to draw the bottle with my eyes. I coursed slowly along the edge, looking deeply just as I would if I were drawing. I made a run around the edge of the label, a contoured path with

one continuous line. Then I jumped to the edge of the blue trigger, cruising into the hollows that fell into shadow, peering in to see every detail I could pull out. I trekked up the side, then slowed myself across an unpunctuated stretch. Move too quickly, I told myself, and you miss something. I downshifted, making myself maintain the same pace no matter how dull the landscape. I arced back up, skated around the edges of the letters on the label, then up and down the corrugations on the cap.

A chair squeaked. I looked up. Numbers flipped on the counter. It was my turn! Twenty-five minutes of my life had been compressed into pure, fleeting pleasure. I capped my mental pen, gathered my papers and approached the clerk on a cloud.

Playing with toys.

Draw toys or models. Nothing against teapots and fruit bowls, but dinosaurs, dump trucks and dollhouses are more fun and more forgiving subjects. If you think it's too easy, turn them at odd angles, flip them over or put a bunch in a pile and draw.

— Jason Das

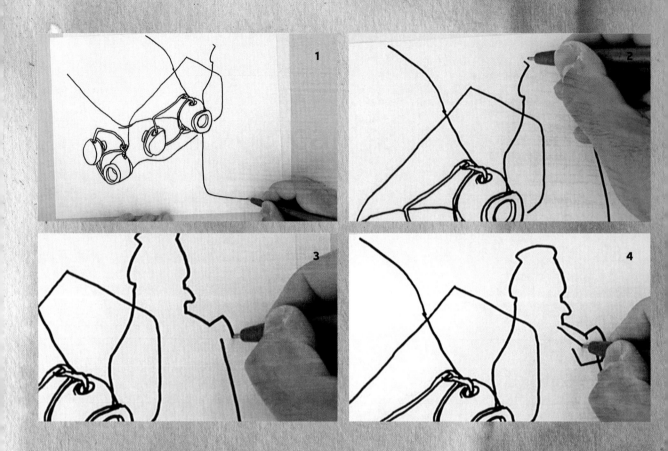

Contour the third.

Working on the same page as the previous two bottle exercises, I'm going to turn the bottle around again and draw it from a third angle. I'll use the same pen and the same technique of slowing down and thinking about the alphabet. But each drawing will be different.

 1) Because I am changing the angle and perspective of the object so that what I am seeing of the bottle is different.

 And 2) because I am different. I have changed in little ways in the few minutes I have been doing this. I am smarter about this bottle. I have learned its landscape better. I am more confident in my lines. Each drawing has changed me and, therefore, the next drawing I do changes, too.

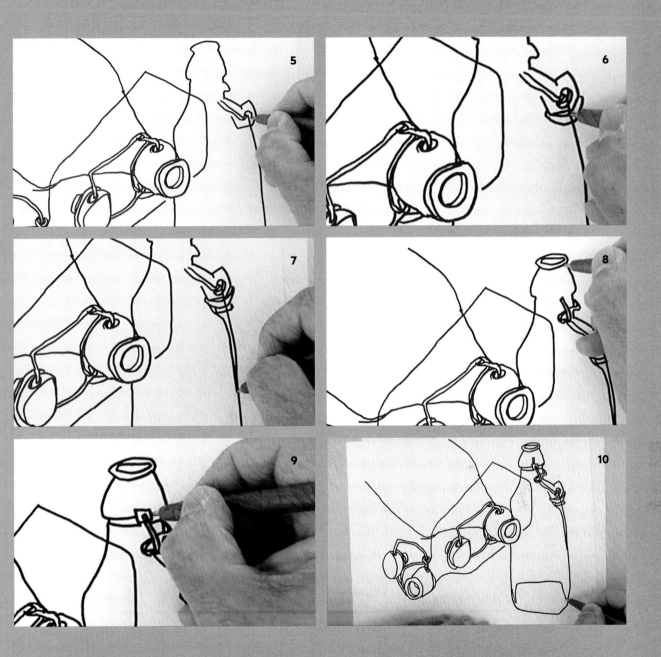

Koosje on contours.

Draw from observation. Do a lot of blind contour drawing. Keep the line continuous. It's fun, and because you don't look at your paper, you can't see the progress, which will help you let go of worrying about the outcome. At the same time, you're training your hand-eye coordination.

— Koosje Koene

Draw big shapes.

Draw big shapes.
Then the shapes within.
Start with the general.
Then get specific.

Try sketching.
Then tightening up.

Squint to see big shapes and not get distracted by the details. (Squinting emphasizes shadows and big planes.)

Compare the height and width of the big shapes.

Turn a complex collection of small shapes into a single, bigger shape.

Compare that group of shapes with another part of the subject to see how your overall proportions are working.

Take a trip.

The most important part of drawing is the exploration
our eyes make. Our eyes are visiting a strange new
world: the surface, the edges of the things we want to draw. There
are so many details to notice, and the more of those details we put
into our drawing, the more accurate the record of our exploration
will be.

Think of a drawing as a map. Your eyes go on a journey, and
your hands record a map of that journey. Then someone else
comes along and looks at your map, and their brain is able to see
the same landscape your eyes did. Pretty cool.

If our eyes are traveling in a Porsche going a hundred miles
an hour, and they are busy tuning the radio station and looking
at themselves in the rearview mirror, not a lot of observation is
going on. Our eyes need to get out there and really explore. They
need to proceed slowly. They need to notice every turn in the
road, every intersection. They have to climb the mountains to see
how tall they are, and ford the rivers to see how deep the water is.

This just takes attention and time. Again, no magic, no talent—
just you, your pen and your open eyes.

Draw what you see.

Draw what you see. Not what you "know."

 Are you seeing?

 Or remembering?

 Drawing takes place in the present. It's not called a "drawn." It's about what you are doing now, not the result.

 Remember: The drawings don't matter. The drawing does.

Continuous line contour drawing.

Here's another great variation on contour drawing. It falls somewhere between blind and regular contour drawing.

Put your pen down and don't lift it up. Ever.

Just keep your eyes tracking over the subject and let your pen follow along on the page.

You can look down at your page every so often to check things (refer to the 80/20 rule on page 63).

You can double back over parts you want to add to.

The drawing will have a cool, vibrating quality. It's wonky but alive.

Seeing the trees, not the forest.

Take a sketchbook on a nature walk and focus on drawing one shape at a time. One leaf or flower or stick. You can really focus on the overall shape and fill in with the direction of the lines or details. It's not overwhelming when you take your time to really look and focus on one, manageable thing.

— Penelope Dullaghan

Kitchen series #1

Let's keep practicing our contour drawing skills.

Open a kitchen drawer and become a kitchen drawer.

Draw a bunch of utensils.

Draw some cups. A blender. The faucet. Some dirty dishes.

Get cooking.

80/20 rule

How much time do you spend drawing, and how much time do you spend looking?

If you're hunkered down over your page, you're missing the view. Look up. In fact, look up most of the time.

Good ratio: For every minute you spend drawing, spend four minutes looking.

If you have a stiff neck and hand cramps, look up!

Kitchen series #2

Raid the larder.
Draw some tin cans.
Some jars.
Open the fridge and
draw a milk carton.
A frozen pizza box.
A ketchup bottle.

GOYA

Coconut Milk

Leche de Coco

A BUNCH OF
STUFF THAT
IS SUPER
IMPORTANT
BUT DULL.

NET WT./PESO NET
13.5 FL. OZ. (40...

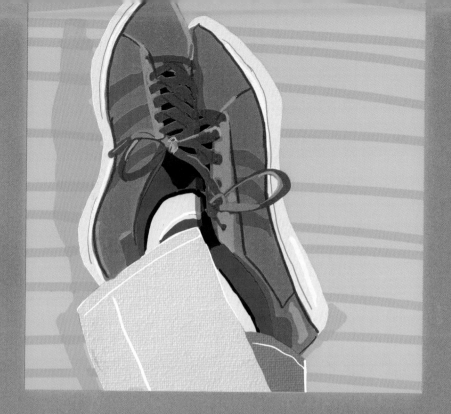

How to spend your time.

Spend more time drawing than:

- Thinking about drawing
- Looking at art
- Reading art books
- Shopping for supplies
- Watching YouTube tutorials on drawing
- Watching cat videos on Facebook.

It doesn't matter what you draw.
It doesn't matter what you draw with.
All that matters is that you draw.
Draw.

over-caffeinated

The zen of Vin.
First, sit and observe and absorb. Plot your page—where should things go? Whether I'm figure drawing, urban sketching or drawing from photo references, I always start by closely observing what I'm about to draw on paper and how it will translate on the surface.

— Vin Ganapathy

How to draw like a natural.

Here's a crucial reminder: Don't skip ahead. Keep working on the basics. Draw simple objects. Draw your lunch. Draw a shoe. Stick to using a black pen. Don't plunge into portraiture or three-point perspective or advanced watercoloring or commissions to paint a church ceiling. Develop your confidence in the building blocks of drawing.

If you can't quite capture what you're seeing yet, write down your observations. Draw an arrow pointing to part of the drawing that explains how the shadow looks, point out the highlight, record what you are learning. Just the act of writing information down helps your memory retain it. Then look for other examples of what you have observed.

The more actively you engage, the more the lessons become second nature. That's really where you want to be: to draw without having to think and to intuitively translate what you see into lines on the page. But, like learning to walk, to tie your shoe, to throw a ball or to drive a car, it takes a lot of repetition to build the neural connections that make a new skill feel natural.

Pro tip.
Lots of drawings look classier with a box or border drawn around them.
— Jason Das

Keeping it in proportion.

Now that we have a basic understanding of how to record lines and shapes, and we're getting a little more confident with drawing, let's talk about proportions. How can we get things to be the right size, relative to each other?

We need to know how wide the object appears to be in relation to its width. We want to know how far down a certain feature appears, how far it goes before it curves. There are a lot of little data points we would like to know.

Measuring the actual object with a ruler won't really help us because we need to take into account our perspective on it. Knowing that a building is a hundred feet high and ten feet wide might be useful if we were architects, but that won't help us capture what we are actually seeing, sitting at its base.

From down here, the building might actually appear a lot wider than it is tall.

The simplest thing is to use your hand or a pen as a measuring stick. Lock your elbow to your side, then hold out your thumb and close one eye. You've seen artists do this in the movies, but it really works.

Position that thumb so it fits the height of what you're measuring. Turn it sideways and see how much of your thumb covers that width. This gives you a ratio of height to width.

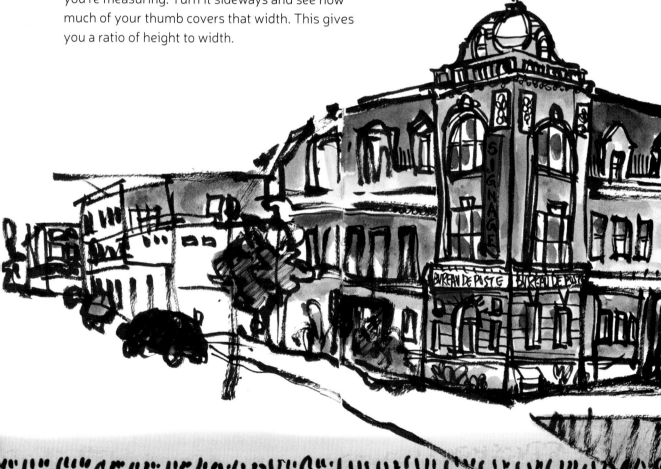

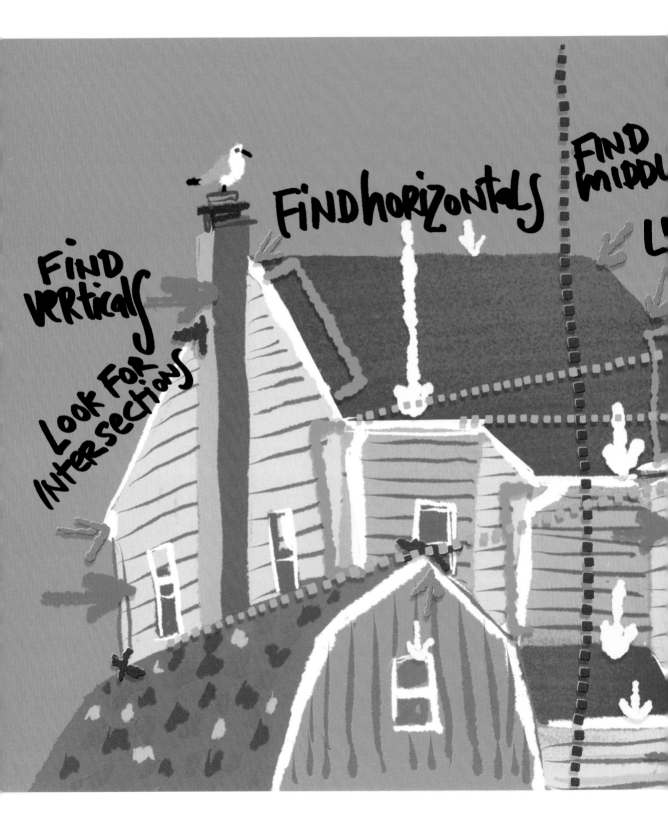

Your pen rules.

Hold it up. Measure against the subject.

Make units, such as the distance from the top of your thumb to the top of the pen.

Put it down on the page. Measure something else.

Take measurements all around the image, not just between adjacent elements.

Measuring is for relationships—not absolutes.

Don't get overly persnickety. Measure to get the big relationships down, then trust your eyes to get the rest.

Not too close.

Keep your eye by your shoulder to keep some distance from the pen.

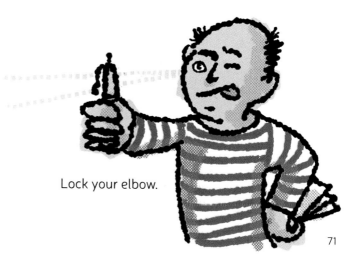

Lock your elbow.

Measure up.

Let's try drawing this table. Use your pen as a ruler. I like to start by measuring the overall shape of the object so I can place it properly on the page and not run out of paper.

The table is one pen high and three pens long. If you want, lay your pen on the page and mark the height of one pen, then the width of three.

Now measure some other landmarks on the table. How deep does it seem to be? Half a pen wide. How far from the left until you can see the back leg? One pen.

And so on. Make a few faint marks as guidelines.

Your pen can also give you a sense of the angles. Turn it to match, then hold that angle and copy it on your page.

You don't have to go crazy with this. We're not making a technical diagram. Just make enough marks to give you a general frame of reference so you can proceed with confidence. Knowing where these landmarks should land will give you a roadmap to place the drawing on the page pretty accurately.

Give it a go.

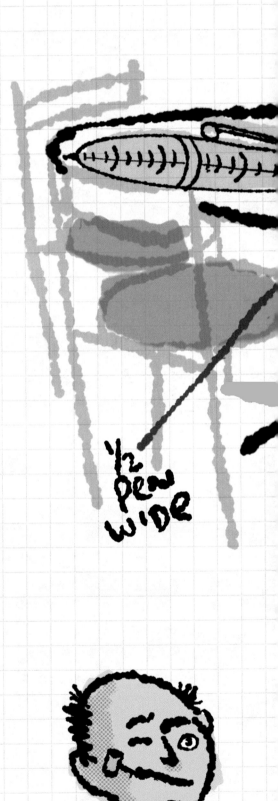

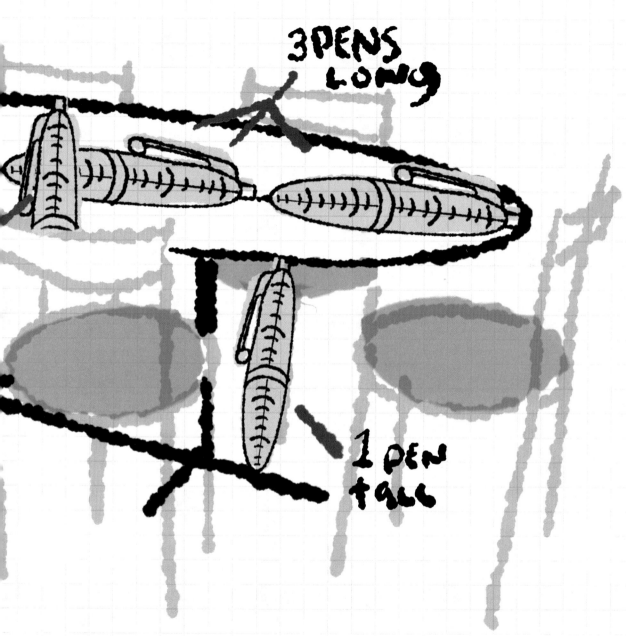

Popeye tip.

Sometimes drawing a 3D object can be discombobulating. You can't judge where things line up, intersect and diverge.

Get monocular. Try closing one eye and looking again. When the world is as flat as your page, things make more sense.

Sketching vs. drawing.

Sketching

- Light
- Loose
- Approximate
- Catch and correct mistakes
- Notice landmarks and intersections and angles
- Squint eyes to see gener-alities and proportions
- Move fast
- Hold pencil higher

Drawing

- Corrected lines
- Details
- Shading
- Slow down
- Focus on details
- Grip pen lower

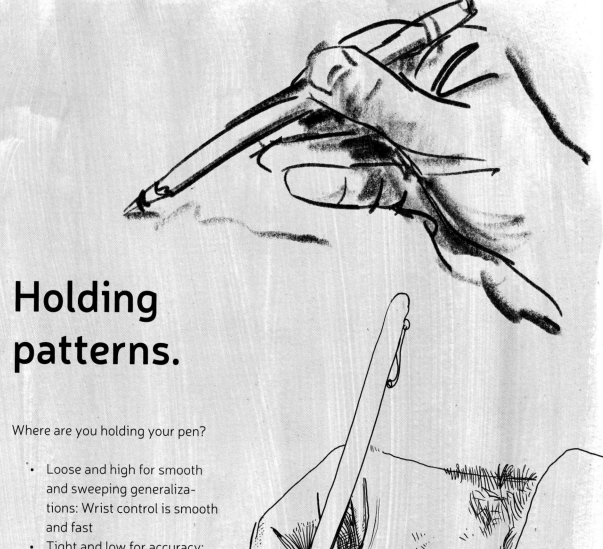

Holding
patterns.

Where are you holding your pen?

- Loose and high for smooth
 and sweeping generaliza-
 tions: Wrist control is smooth
 and fast
- Tight and low for accuracy:
 Finger control is slower and
 smaller

Realism isn't real.

Here's the thing—realism is an illusion. Drawings don't depict reality. They only capture our interpretation of it.

There are many ways to see, and no one method is correct.

That's why Warhol, Picasso and Modigliani can all draw a body and it will be so different. Not because one draws better than the other, but because they all see the world differently. And so do you.

That's a really important thing to remember as you practice drawing.

The drawings that, at first, seem "wrong" are really just steps along the journey. Important steps. They tell us who you are right now. A person who is emerging, learning and discovering. That's honest and interesting, far more interesting than perfection or photorealism.

Your drawing captures who you are, where you are, the angle of your head, the fact that you have two eyes that take in different information and yet you are making one drawing, one depiction, a record of all the information you are picking up as you look. It's a complex business, and it will take a little time to master. You have to combine all that information, all the feelings you have about the object, the place, the moment and yourself. Whether you know it or not, all of that is being described in that line. If you keep erasing and redrawing it, you will lose that moment, that truth, and replace its hesitation and second thoughts into something more perfect, but more lifeless and bland.

I spent two years drawing with a pen before I started drawing with a pencil. And even now, the pen is my tool of choice. The pen keeps me honest, keeps me learning, and keeps me on the path to drawing with confidence.

Trust me—it will work for you as well.

Salli on her bike.

I don't believe I draw very well, yet I've come to embrace my drawing style. I prefer to keep a sense of whimsy in my drawing and not always worry about accuracy. However, there are still many things that I need reference for—like a bicycle! If I try to draw a bicycle while looking at a real bicycle or photos of bikes, I tend to tighten up and draw in a more realistic style, which really never goes well. Instead, I take a few minutes to look at the object (or photos) and then set it aside and out of view. I draw whatever my mind remembers, and I'm able to retain my own drawing style. If I miss some details or add things that aren't there, I'm okay with it because it feels more like "me."

— Salli Swindell

Negative thinking can be very positive.

Sometimes the best way to draw something is to draw what isn't there.

For instance, if you want to draw a chair on the floor, it might be best to start by drawing what you see of the floor rather than drawing the chair itself. Or draw a city skyline by drawing the sky behind it.

This concept is called negative space, and it is a very useful perspective to add to your tool kit.

At first this approach can be tricky; your brain may struggle to see negative space, but with practice everything will click.

Let's try it with some letters. Draw everything—except the letters themselves.

Draw just the black shapes and ignore whether they are parts of a letter. Notice how some black shapes encompass more than one letter. Notice relationships, proportions, all the same stuff we do when we draw anything.

Drawing a blank.

Look for the blank spaces in your subject
and draw them first.

Notice blank spaces as much as you
notice landmarks.

What isn't there defines space as much
as what is.

More negative space.

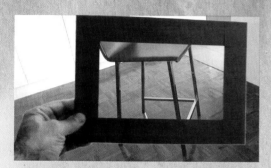

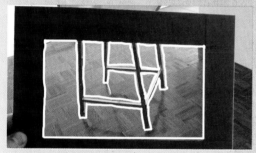

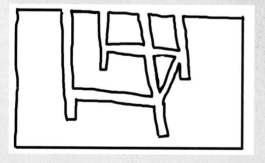

Let's try looking at negative space in a 3D object.

But to make things easier, we'll use a viewfinder to define the edges. You can cut one out of cardboard or use a picture mat from a frame.

Just close one eye, and the 3D scene becomes two dimensional.

We'll draw this stool. Let's focus on shapes we can see through the legs. I see a sort of trapezoid here. A triangle there. A rectangle here. Another trapezoid.

As we draw the negative shapes, the positive shape of the stool emerges.

You don't need to make the whole drawing this way every time, but when you get disoriented or lost, this technique will help you find your way.

With practice, you won't need to use the frame every time, but hang onto it if it's helpful.

Your turn. Pick out a chair and draw the negative space around it.

8 tips from Cathy.

1. Be prepared. Always have something with you to draw with, even if it's a used envelope and a ballpoint pen. It doesn't need to be fancy, archival, hand-bound, special . . . in fact, sometimes that puts people off, and they're reluctant to use the good stuff!
2. If you don't have anything to draw with, look around! I've used a broken stick I've picked up off the ground, a "wash" of mud or berries, and a pen I cut from a goose's feather.
3. Remember, they're making more paper, even as we speak. It's okay to use it up, mess it up and play with it.
4. Go into it with an attitude of fun, not competition or needing to show your work. Explore. Play!
5. Try kids' paints for a change, or a set of crayons. Use sidewalk chalk—yes, on the sidewalk.
6. Work small. Make a lot of quick little drawings on a page. If you don't like one, paste a piece of paper over it and add on top of that.
7. Draw guidelines for yourself, if you want. There are no rules!
8. Work big, with big, sweeping strokes. Don't worry about the detail, just get the shape, the motion.

— *Cathy Johnson*

Dealing with disasters.

It happens. You work on a drawing, and it just doesn't seem right. You adjust, you redraw and, still, it's a dud.

It's easy to convince yourself that this mess is a sign—proof positive that you suck, have no talent, will never get it—but you mustn't let that crazy negativity stop your progress.

This experience is not the same as failure. It's a struggle, but it's also a lesson. Every bad drawing means more good ones ahead. Trust me.

Let me give you an example. Picasso. No question the guy was a genius, right? But think of what we know him for. Maybe a small handful of works: Guernica, Demoiselles d'Avignon, the cubist still life thing, the crying lady, the blue guitarist. . . .

One of the greatest artist of the 20th century, and we know him for as many pieces as you can count on one hand. Was that all he made? Did he succeed with every single piece? Of course not.

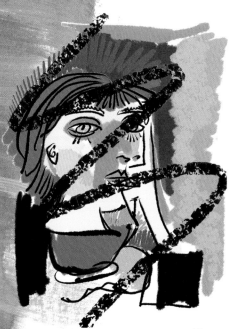

Picasso left 50,000 works of art when he died—50,000 that are considered good enough to be counted as artworks, to be collected, exhibited and sold at auction. For each of those he made hundreds of sketches, false starts, rejects and junk that hit the dumpster.

Picasso made more works of art than I've made cups of tea, yet he's known for that small handful. A handful that only came about because he filled all those dumpsters with crumpled paper, shredded canvases and lumps of dried clay.

Art is a process—a lifelong process. And you must steel yourself to the mishaps. Every artist does. You can, too.

The best revenge is to turn the page and start the next drawing.

How to accurately measure your progress.

So many fledgling artists begin their drawing journey by gazing at the far-off horizon, then they burst out of the starting gate, trip over their own feet and fall flat. They begin by focusing only on the end result of learning—that perfect drawing—then despair when each line they make fails to immediately achieve that goal.

What they are overlooking are all the individual steps they are making toward that objective; the small but crucial improvements they are making every day.

I know this because it happened to me, too. Early on, I'd flip through my first handful of pages and grimace. They all sucked. I sucked. And I'd never get any better. But had I been paying attention, had I been willing to be objective instead of brutally critical, I would have noticed how much actual progress I'd been making. That my lines were more confident. That I'd tackled complex new subjects. That I was starting to see how to really see. When I look back on my early sketchbooks now, I can see that, even after a month or two, I was getting better and better. But at the time, all I could think was "I will never get there."

Why? Because instead of comparing me with me, I was comparing me with da Vinci, or with my friend the professional illustrator or with all the artists who'd inspired me to start drawing. The first bar was way too high. I'd just started to jog, and I was beating myself up for not running a marathon in under three hours.

It's essential to recognize that your judgement of your own progress is far from accurate. I guarantee you are doing better than you think you are because, again, your perspective is distorted by the dream you have of where you want to get to. And because you feel like an impostor who's pretending to be an artist but can't draw a stick figure.

So stop obsessing over how far you have yet to travel and check out the ground you've already covered. Spend less time on self-criticism and more on your next drawing.

Someone probably already said this but . . .

We think of genius as the ability to dream up something never seen before. But originality is overrated.

What matters more is reacting and responding and refining and adjusting and tweaking and struggling and sweating and polishing and finishing and delivering and making a difference.

AHA! is exhilarating, sure. But now the hard work begins.

Seek mistakes.

If you're drawing progress seems stuck, give yourself a drawing critique.

Learn by evaluating where it isn't quite accurate.

Make a game out of it. Earn points for finding mistakes. How high can you score?

Can you find 100 mistakes?

Yay!

You don't improve by ignoring your mistakes. The more you notice, the more you can improve.

Be ruthless but kind.

The point is not to leave your drawing a smoldering wreck. It's to give you some ideas for things to work on.

Your goal isn't perfection. It's just progress.

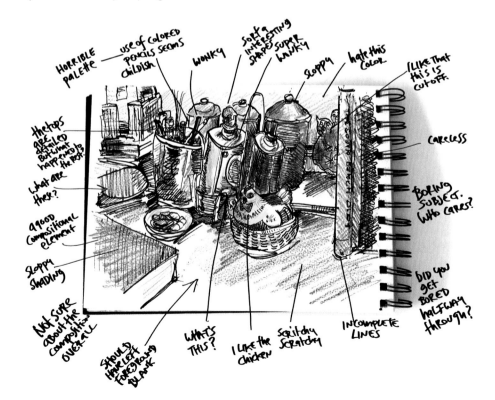

Critique vs. criticism.

Critique =
 Improve
 Focus
 Learn
 Clarify
 Inform
 Objective

Criticism=
 Diminish
 Destroy
 Undermine
 Judge
 Personal
 No

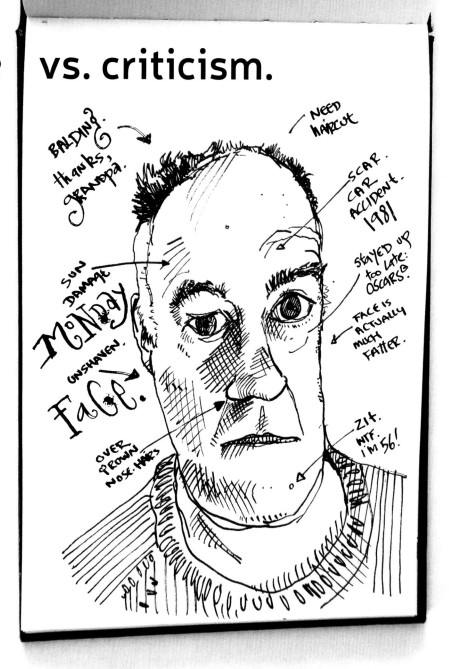

Keeping the fun
in fundamentals.

Teaching yourself to make art is a lifelong endeavor. Books and courses will help, but it's up to you to keep the work interesting and relevant.

Look for creative ways to keep practicing the basics, like contour drawing, proportions, foreshortening, tone, shading, volume, etc.

Don't make drills dull. Find ways to mix things up. Draw things that mean something to you.

Instead of setting up artificial subjects like bowls of fruit or vases of flowers, draw the contents of your fridge. Draw the roses you got for your birthday and write about how you feel getting a year older. Instead of drawing naked strangers in a life drawing class, draw your naked spouse, your cat, your boss. Rather than doing drapery studies, draw the shapes your feet make under the covers on a Sunday morning.

Be inventive. Be fresh. Be personal. It's an adventure, not a chore.

How to motivate yourself.

Improvement takes practice. Guaranteed. But if you don't want to practice, you won't. It's crucial to stay motivated, even if you're not on the verge of a career retrospective at the Guggenheim.

One way to motivate is to set yourself small goals that you know you can achieve. For instance, do a drawing every day. Even if it's just for two minutes, pick up that pen. Or commit to filling an entire sketchbook in the next month, then celebrate by buying a new art tool.

I spent a year drawing with one type of black pen, then I allowed myself one gray brush marker. A month later, I added a different gray, and I slowly worked my way up to a bag full of color markers over a year. The next year, I bought myself a cheap watercolor set. The year after that, a really good watercolor set, and so on.

Try focusing on a single daily subject for a month. Pick a subject you find interesting but don't try to make an "art statement." It's just a theme to practice variations upon. I drew my teacup every single morning. I drew a selfie every day. The view out my kitchen window. Cars on my block. A photo from the front page. A different dog every day. I get a sense of accomplishment when I see how much I am drawing, not just how "well" I am drawing.

Whenever you complete a sketchbook, spend some time with it. Look back at each page, study what you did, how your work has changed. Get out your phone and make a video as you flip through the pages. Share it online with friends you can trust. Their support and encouragement will help keep you going.

89

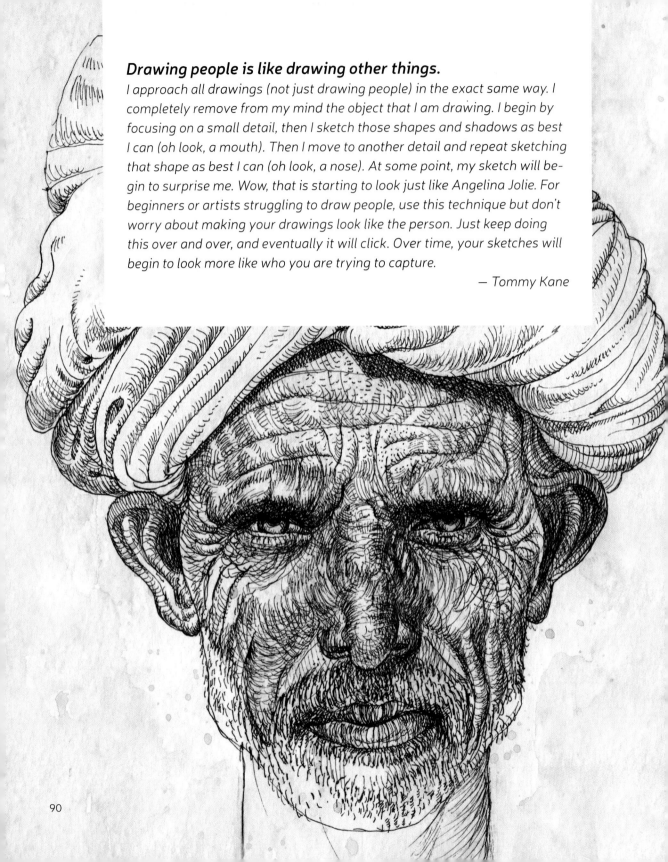

Drawing people is like drawing other things.

I approach all drawings (not just drawing people) in the exact same way. I completely remove from my mind the object that I am drawing. I begin by focusing on a small detail, then I sketch those shapes and shadows as best I can (oh look, a mouth). Then I move to another detail and repeat sketching that shape as best I can (oh look, a nose). At some point, my sketch will begin to surprise me. Wow, that is starting to look just like Angelina Jolie. For beginners or artists struggling to draw people, use this technique but don't worry about making your drawings look like the person. Just keep doing this over and over, and eventually it will click. Over time, your sketches will begin to look more like who you are trying to capture.

— Tommy Kane

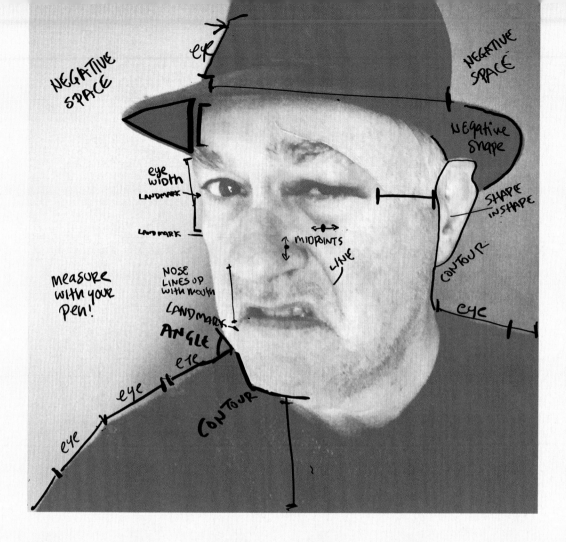

The ABCs of portraiture.

Let's try Tommy's suggestion.
Here's an unflattering picture of me.
Break it down into shapes and lines.
Don't think eyes, mouth, potato nose.
Use the alphabet to understand it in terms of
abstractions, proportions and relationships.
Make me look good, yo.

Stranger danger.

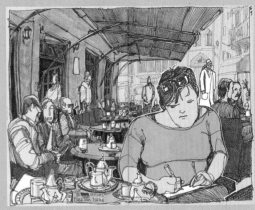

Miguel Herranz

People are everywhere, waiting for you to draw them. Be not afraid.

Go to a place where people are just hanging around, killing time, reading their phones, picking their noses. A train station, a coffee shop, a library, a doctor's waiting room.

Pick a corner and sit with your back to the wall so you don't have to worry about someone looking over your shoulder as you draw. Take your time and find an interesting subject, ideally one napping or lost in thought or their Facebook feed.

First, let your eyes just cruise over their features while your pen records a blind contour line of what you see. Don't think about drawing features or the names of things. Forget "collar," "sunglasses," "nose ring," "toupee."

Once you've observed their facial features, keep going. Work your way down the shoulders, the elbows, the arm rest, the table, the glasses, the cutlery, the chair legs, the shoes, the floor tiles, and on and on. Keep drawing the contours until you feel done.

Now, look at your page and then back at your subject. Start to fill in details from observation. Draw the buttons, the wrinkles, the tattoos.

You may be dismayed that your blind contour lines are wonky and weird. Don't be. And do not correct your original lines. Just fill in the details. I promise you will end up with a drawing that looks like your subject but also has loads of character and interest. Remember, you are not correcting your original observation. You are enhancing, adding information, making it richer.

If someone happens to come over to you and ask what the hell you're staring at, just say, "I'm an artist, and you have a great face. I hope you don't mind." I doubt they will. And worst case, you'll have a great story to tell once you get out of the ER.

Draw a selfie.

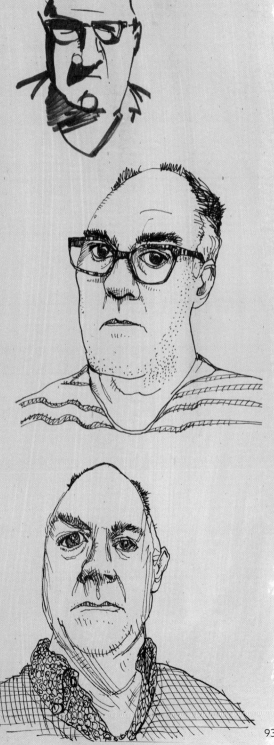

Still afraid of drawing other people? Then practice drawing the one model who is always available and never demands a paycheck—you.

Get out a mirror and draw what you see. Try a blind contour first. Start with your left eyebrow, work down around your ear, over the top of your head, around the other ear and around your jaw. Then work your way across one eye, around the nose, over the other eye, then draw your mouth, your neck, your décolletage. Then look down and fill in the details.

Do this every morning. Use the alphabet to break your face into its component shapes. Try different marks to indicate your eyebrows, your neck tattoo, your nostril hairs. Measure your features against each other using your pen or thumb. Use the frame of the mirror to help you create a boundary to your image and a tool or measurements.

Draw yourself facing left then right. Put the mirror up high and draw yourself from that angle, then lay it flat on the table and look down.

Keep going.

Tip: Try to avoid using photos. The mirror is much more valuable practice. It will help you deal with a shifting subject, with depth of field, with drawing from reality.

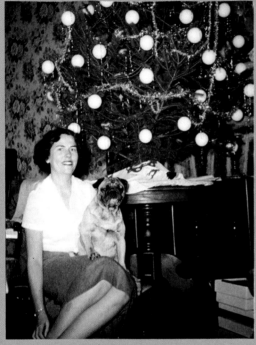

BRON: www.vintag.es

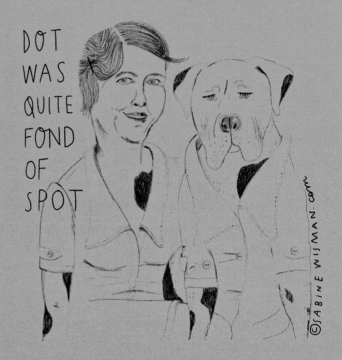

DOT WAS QUITE FOND OF SPOT

©SABINE WISMAN.com

Personal image bank.

Drawing from photos isn't cheating. Great artists have been doing it forever. But pick your picture well. Photos are never as versatile as reality, especially random ones of strangers you find on the Internet. Instead, draw from your personal image bank. Open a family photo album and use it as reference. Draw your great-aunt one drunken New Year's. Your obnoxious cousin at the swimming pool. Your sister and her prom date. Take a real close look and start drawing.

— Sabine Wisman

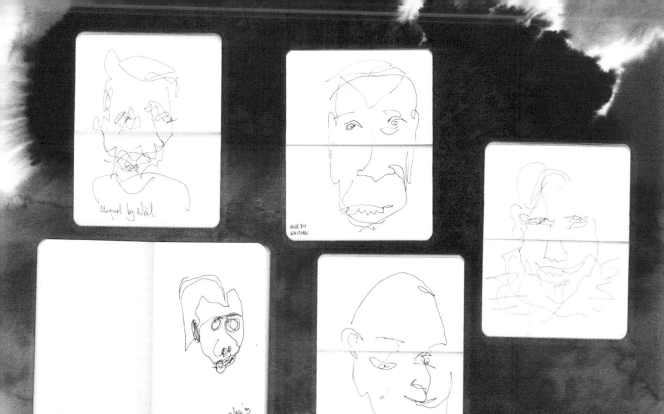

Throw a portrait party.

I love a good portrait party. It's a great way to encourage people to draw. Every one gets a thick pen (Sharpies are good) and large sheets of paper.

I explain that people will be drawing without looking at the paper and without taking their pens off the paper. No one needs to worry about how the drawings will look. They're blind contours, after all.

People pair off and we set a timer. We start with thirty seconds. Everyone draws their partner, and then we move on to the next person.

I gradually increase the time periods. Five to ten drawings are good to get people to start to really look at who they're drawing, loosen up and gain confidence.

Generally, people are surprised and excited by the quality of their drawings. Adding cocktails helps, too.

— *Michael Nobbs*

Gesture drawing.

Here's an age-old problem: People just don't stand still. They always seem to have something better to do, somewhere better to go, rather than to just stand in one place and let you draw them.

The solution is called "gesture drawing."

The trick is to draw quickly and loosely, focusing only on the general shape and direction of the person's posture. All that matters are the bare essentials, no details.

Try to see the main line of the person's pose or movement. Are they an S-shape? A 45-degree angled line?

Try to capture the line of the spine. The head can be just a quick circle. Triangle feet, a rectangle for the torso. Stay loose and sketchy.

Just glance and create a mental picture, a super-rough snapshot that reduces them to a stroke. It's almost like writing letters, taking notes, fast and calligraphic.

You just want to capture the movement of the person. And you want to do it fast, before they get away.

Try it out anywhere people are walking or doing repeated motions, like dancing or playing basketball.

Fill a page with little squiggles to capture the gestures. Fill another page.

Do it whenever you're sitting in a public space full of moving, sitting, animated people.

Keep practicing, and soon you'll develop a shorthand for gesture and an eye for movement.

Later, take your favorite gesture drawing and keep working on it, adding details and refining the lines.

Be careful. Don't go overboard and lose the original energy that comes from gesture drawing. Stay loose.

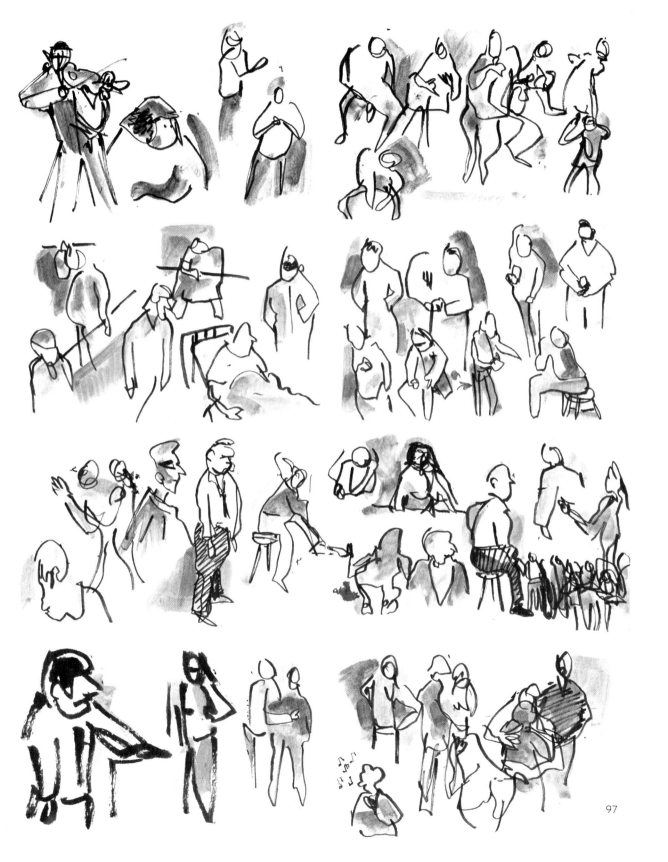

Leftie selfie.

Time to mess with yourself and get creative with some variations on your daily selfie.

Get sinister (that's Latin for left-handed). Draw a selfie with a pen in your nondominant hand. This is great fun because your inner critic will check out. A left-handed drawing can't be perfect, so you can chill out and express yourself.

Get a concave or convex surface, like a coffee pot or the edge of a chrome toaster, and use it as a mirror. Draw what you see. You'll look like Quasimodo, and your drawing will stretch.

Next, try drawing with a fat Sharpie. Simplify your features. Make a caricature. Make your nostrils even bigger. Your eyebrows thicker. Triple or quadruple your chins. Give yourself big eyes, then smaller ones. Have you captured the True You yet?

Lefty and righty.

This is really fun and kinda spooky.

You're going to draw a portrait with both of your hands at the same time.

Hold a blue pen in one hand and a red pen in the other. Now start to draw with your dominant hand. As you do, your other hand will mysteriously start to draw along—only in reverse.

Sounds terrifying, I know. It's actually incredibly doable.

These two drawings have different personalities, different line quality. It's as if there were two artists living in your head at the same time!

Try switching and make your other hand dominant. Now what happens?

Creative license.

In copying, we can make mistakes.

 Mistakes break rules . . .

 . . . which lead to new creations.

 What if you try to make mistakes?

 Pick a photo to draw from and let's do a drawing that doesn't look much like the photo.

 What do I mean? Well, instead of trying to get every detail and proportion correct, use elements from the photo as a springboard for your own ideas.

 If you make a mistake, make it even bigger. Turn it into some thing new. Look for interesting shapes and exaggerate what makes them interesting. Let a line go crazy.

 When you're done, notice the parts that look like the photo. Amazingly, you'll still see a likeness to the photo even though you didn't try slavishly to copy it.

Don't get lost in the details.

You don't need to draw every hair on someone's head or every leaf on a tree.

 You can add details just in the shadows to do double duty.

 Or sprinkle them here and there.

 Or add details with a different pen or pencil.

 Sometimes when you add too much detail, the drawing gets lost. The energy and the things you were trying to say with it are lost in a thicket of hairs and leaves.

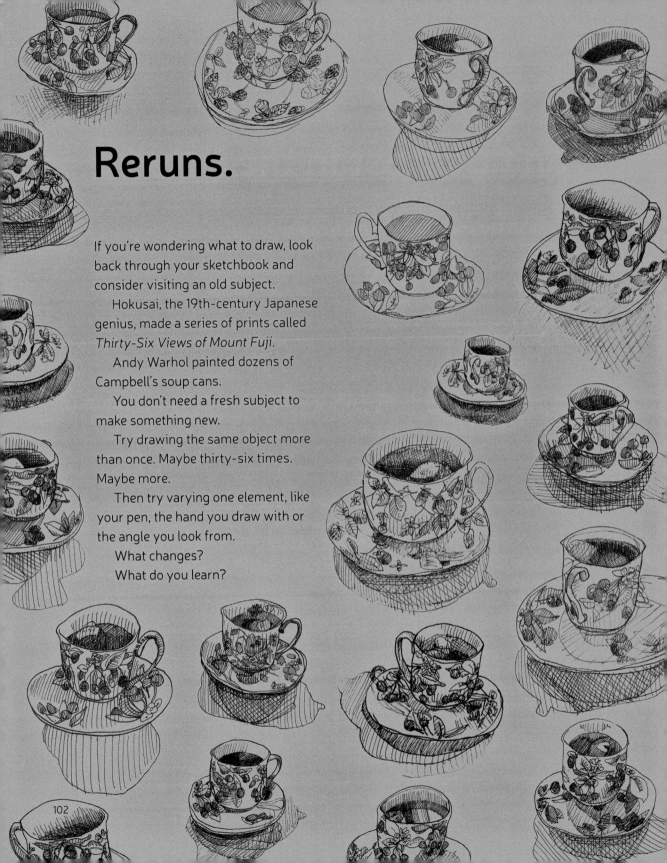

Reruns.

If you're wondering what to draw, look back through your sketchbook and consider visiting an old subject.

Hokusai, the 19th-century Japanese genius, made a series of prints called *Thirty-Six Views of Mount Fuji*.

Andy Warhol painted dozens of Campbell's soup cans.

You don't need a fresh subject to make something new.

Try drawing the same object more than once. Maybe thirty-six times. Maybe more.

Then try varying one element, like your pen, the hand you draw with or the angle you look from.

What changes?

What do you learn?

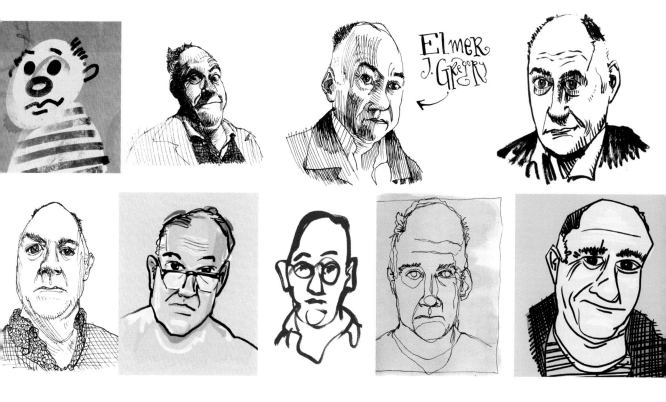

Do a month of selfies.

Make a pledge to draw yourself every single day this month. Establish a morning habit as you have your first cup of coffee. Just prop up your mirror, open your sketchbook and go to it.

Without even trying, you will capture who you are at this moment in time. Drawing what you look like, but also how you feel. The lines you draw, the look on your face, they will all sum up things deep inside you.

A selfie a day is an insightful, creative form of self-analysis. It's a great way to practice your people drawing skills and much cheaper than psychiatry.

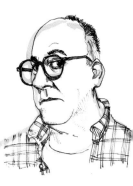

Draw 40 dogs.

Here's a fun assignment I gave myself. Feel free to try it, as well.

Draw a different kind of dog each day for a month. I ended up drawing over a hundred, and I want to keep going.

Draw dogs you know, dogs from the park, dogs from Google, dogs that live only in your imagination.

Stay simple and try to give them personality and expression.

Consider all the things that make up a dog: nose, whiskers, tail, teeth, collars and ears. Vary them, explore them, distort them.

And try feeling something about each dog as you draw it. Cute. Strong. Fierce. Funny. Greedy. Smelly. . . .

Let's shine a light on tone and shadow.

So far, we have been focusing primarily on contour line drawing. Now that you know how that works, it's time to learn about how to add shading and tone to your drawings to give them dimension.

It all begins with light, the source that strikes an object from one or more directions and creates shadows. Light gives dimension. It makes it look real.

Now, if you have, say, a teacup sitting on a table in a room with windows, it may be difficult to fully understand the shadow because the light seems to be coming from everywhere. But with careful observation, you'll be able to see what light source dominates.

First let's make our own light source and make it extra bright. Take a desk lamp, or even a flashlight, and aim right at your cup. Try moving the light and watching how the shadows shift. It's not all black and white, is it? There's a major shadow on one side but there are subtle shadows, too, including gradations from light to dark. And there is reflected light, as well, where the light hits the teacup and bounces back.

Do a quick line drawing of the cup and make notes about the following with words and arrows:

1. Source and angle of light
2. Shadows
3. Reflected light

Next, let's talk about this in theoretical terms.

Draw a circle and pick where the source of your light will be. Now let's use marks to make shadows and turn the circle into a sphere.

The half of the sphere facing away from the light will, of course, be darker. Where would the shadow it casts be on the floor? Notice that the floor might reflect light back on the sphere, light-ing the rim of the sphere that's in the shadow.

What if you add a second light, maybe one that's not as bright?

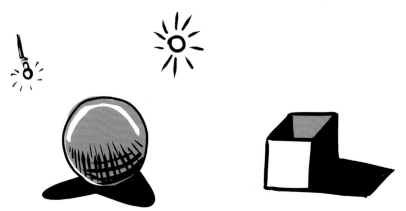

Now let's go from theory to practice. Take a ping pong ball or an egg and move a light around it—see how the theory holds up? What else did you observe?

What if you add texture?

A cube?

A donut?

A cylinder?

A pyramid?

As you practice making theoretical models, keep observing how light falls on the objects around you. The more you do, the more it will become second nature to add dimension to your drawings.

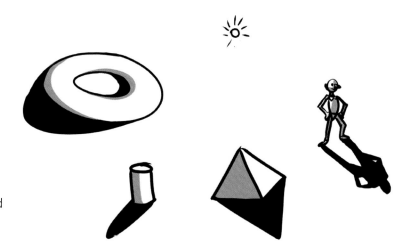

Crosshatching without getting cross-eyed.

Hatching is the term we use for those patterns of lines that make up tone.

When they cross over each other, we call it crosshatching.

There are many different ways of making hatches. Straight lines, curved lines, circles and other shapes. Checkerboards. Tweed.

Stippling means using dots instead of lines to indicate shading.

You can decide to use only one pattern in a drawing or to mix it up, perhaps to indicate different textures.

You can make your lines consistent (but don't use a ruler—you're not a mechanical engineer) or loose and expressive. Your call.

When lines are closer together or heavier, they indicate a darker tone. I recommend starting with lighter hatching and then building it up. You can always make something darker, but you can't take ink lines away.

Try to keep your lines parallel and consistent. Don't scribble.

Try different directions.

You can also use hatches to make gradations, going gradually from light to dark.

Hatching can also indicate color as well as shading. Or both.

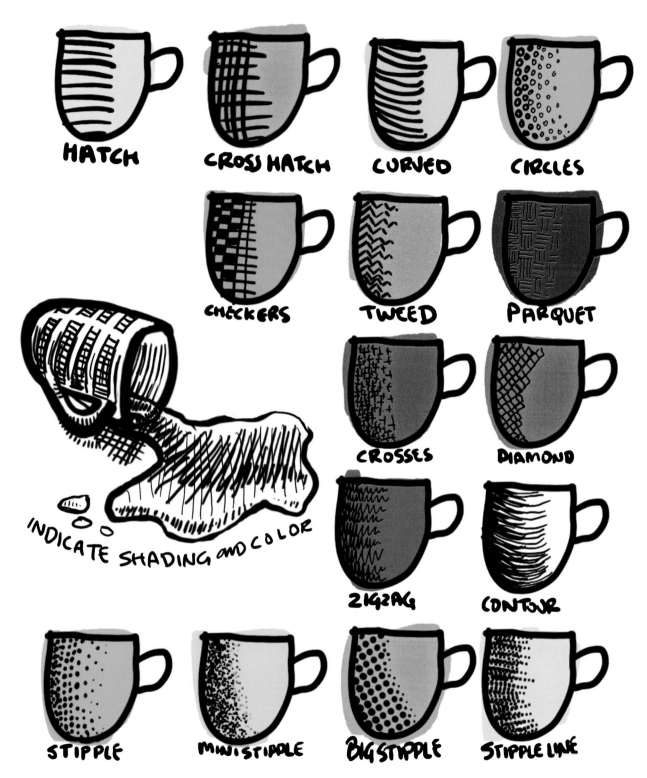

HATCH

CROSS HATCH

CURVED

CIRCLES

CHECKERS

TWEED

PARQUET

INDICATE SHADING and COLOR

CROSSES

DIAMOND

ZIGZAG

CONTOUR

STIPPLE

MINI STIPPLE

BIG STIPPLE

STIPPLE LINE

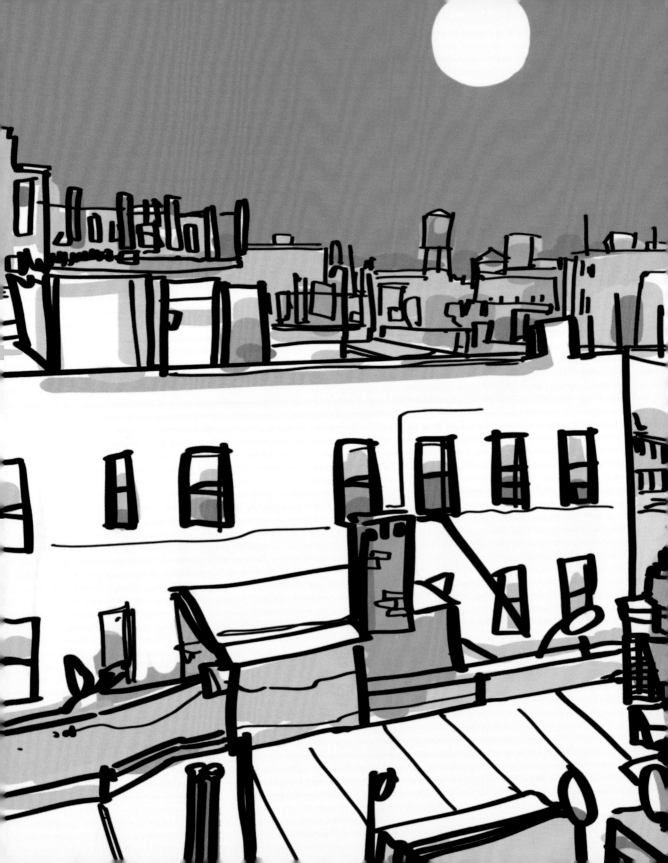

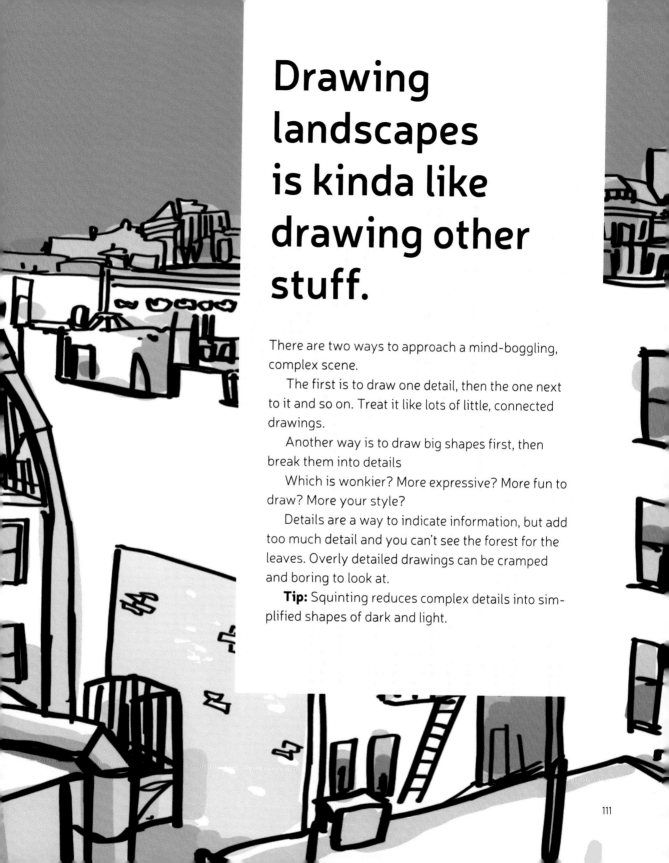

Drawing landscapes is kinda like drawing other stuff.

There are two ways to approach a mind-boggling, complex scene.

The first is to draw one detail, then the one next to it and so on. Treat it like lots of little, connected drawings.

Another way is to draw big shapes first, then break them into details

Which is wonkier? More expressive? More fun to draw? More your style?

Details are a way to indicate information, but add too much detail and you can't see the forest for the leaves. Overly detailed drawings can be cramped and boring to look at.

Tip: Squinting reduces complex details into simplified shapes of dark and light.

The point of perspective.

Here's the main thing you need to know (which you already do know).

If it's far away, it's small. If it's close, it's big.

That change in scale is geometric. Further, further, further = smaller, smaller smaller.

Is there a precise scientific formula for this relationship? Don't know, don't care.

If you really want be particular about it, you could draw the lines that define that change in scale. This is called "receding to the vanishing point," which sits on the horizon.

But don't be too particular. You don't need to be to make cool landscape drawings.

Begin at the top.

When drawing buildings, don't worry about perspective. Start drawing the sky instead of the buildings. Once you have the outline of the sky, you'll have many reference points to build your drawing on.

— Koosje Koene

The spiral technique.

Here's a great technique for drawing a complicated scene with lots of elements and many levels of depth.

Start by drawing a single element that catches your eye, and then slowly spiral outward to capture the scene around it.

I'm going to start with the statue, then draw what's to the left, to the right, above and below it. Then I slowly keep expanding.

I draw the buildings that butt up to the left, the railing below and the tree to the left.

Then I keep going, adding the people who adjoin the railing. Then the scene between their heads. Then I branch up and draw the big building above. On the next sweep, I draw what's above and below the tree on the left. Finally, I fill in the sky above and the building to the right.

Don't go too far too fast—just draw the next slice of elements you see as you slowly widen out. Don't worry about the final composition and, instead, just start to draw and improvise. Keep looking for reference points for size comparisons and slowly add more elements, building out in a spiral.

In time, you will capture the whole scene in a pleasing composition without being intimidated by how complex the scene first appeared to be.

— *Miguel Herranz*

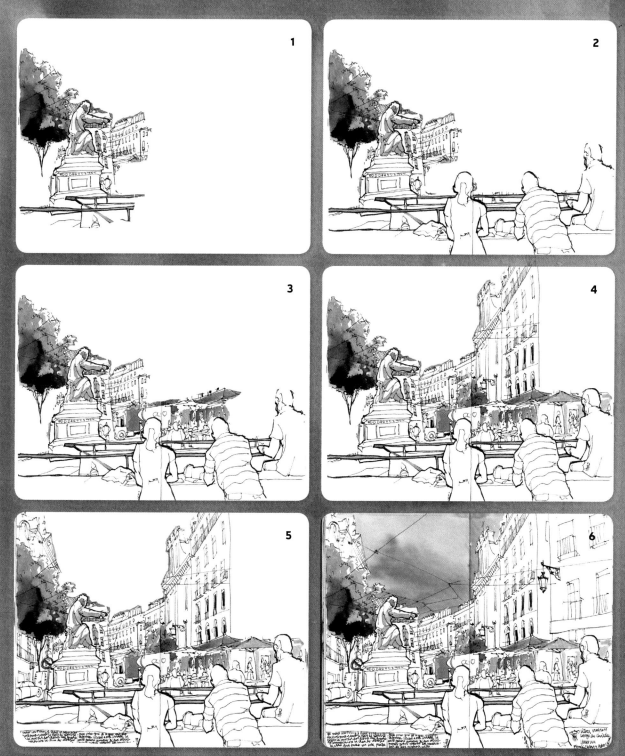

Miguel Herranz

Going deep.

My sketches are time consuming; I rarely complete them in one shot. So I've incorporated a technique that makes compelling finished drawings. A sketchbook page of mine may involve drawings that were done in five or six different sittings in completely different locations and circumstances. I fit together separate drawings without any preplanning, just by feel and experience. I can pour endless detail into seashells, flowers, toys, or whatever else happens to be in front of my brain at a given downtime. Sometimes I will open a sketchbook and forget I've drawn a few random items on a page. Then I just keep going to see where it ends. Occasionally the objects are related, but it's not important. The end results are fascinating.

— *Tommy Kane*

All together now.

We've talked a lot about breaking down the things we see into smaller parts. Into the letters of the drawing alphabet, into boxes, into measurements. And the fact is, if you can break down the elements of something small, like the square through a view finder, you can use the same approach to tackle something bigger, like an entire room.

So let's try using all of our tools: the alphabet, contours, landmarks, measurements—even negative space and gesture—to draw something more complex. A whole scene. It could be the contents of your pantry. Your garage. A bicycle. A room in your house.

This will be a longish exercise. You may spend a whole hour (or much more) getting down all the details. But don't be intimidated. There are lots of elements, but we will break them down into bite-sized chunks and build the whole picture part by part.

Sit down, get comfy and draw a frame. Then start taking some measurements. How much of the scene will fit on the page? Let's say from the top of the cabinet down to the floor where the dog bowl sits.

Now use that measurement to see how much of the width of your scene you can fit in the frame. Maybe just up to the second stool at the right.

Now look at the structure. What lines and shapes are the most important? Measure some of the elements within those shapes. Set down a few marks to indicate where they'll go. Now draw those main lines.

Next, start to look at the details in each of those shapes and mark down where they go. Where do things line up? What are the landmarks? How does this section over here compare with that one over there, and so on.

Now use an even tighter lens and look at the details within the shape. Work your way across the scene, recording details and then the details within the details.

Look for negative space. The ceiling is a negative space that defines the walls. Look at that shape carefully. Its edges help us place another section of the wall.

As you can see, no matter how complicated or big a subject, you can draw it. Just break it down into pieces, take measurements and notice landmarks, and all the pieces will fit together.

These principles work no matter what you are drawing. A bowl of fruit, a cityscape, a Maserati, a person's face, a cat asleep on the window.

All you need are your drawing alphabet, your pen ruler, your negative space, and a plan to break it all down and put it back together.

Notice that I never mentioned talent. You don't need it. Take your time, believe in your ability and you can draw anything perfectly well without talent.

"After" drawings.

Ages ago, when we first started this
journey, I asked you to draw a few things.

Let's try that again.

Draw:

A person

A car

A tree

A building

A mug

Give yourself a hand.

Remember the very first thing I asked you to draw? Your hand. Now, let's try that again. But instead of just laying your hand flat on the table, arrange it in some way, perhaps with some of your fingers stretched out while others are curled or crossed over each other. Create an interesting pose that's comfortable to hold.

 Now draw your hand. Use everything we have learned: landmarks, angles, the ABCs, negative space. Spend ten minutes drawing your hand and see how far you've come already!

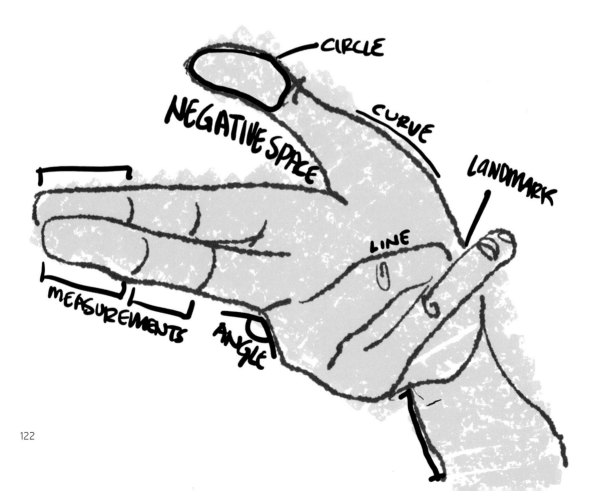

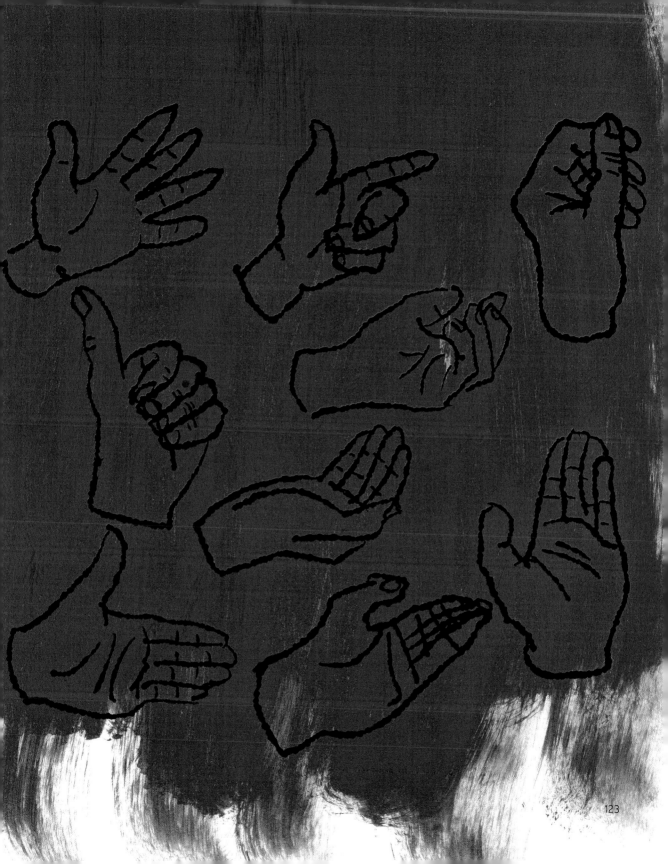

What next?

You now have all the tools you need. Let's go over them one last time.

- Talent doesn't matter.
- Be confident and you can do it.
- Use a pen to help you commit.
- Be patient and explore.
- Realism is subjective.
- Focus on the process, not just the results.
- Remember the drawing alphabet: straight lines, curves, angles, dots and circles.
- Look for landmarks.
- Be willing to live with mistakes.
- Take measurements.
- Identify negative space.
- Use gesture to capture the whole.
- Break the whole into parts.
- Practice. Practice. Practice.

That's pretty much it. Drawing isn't magic. It isn't luck or God-given talent. It's just a bunch of tools, and you now have most of them in your kit.

You're ready to draw the world. You have passed your road test. Now you need to practice. You need to carry around a sketchbook and a pen and keep drawing the stuff around you. The more you do, the more confident you'll be, and the more pleased you'll be with the results. In time you'll be ready to learn about volume, shading and perspective. But you don't need any of those tools yet. Just get out there and draw.

Have a blast!

Thanks.

This book would just be an empty sketchbook were it not for the help and support of loads of wonderful creative people.

All of the faculty of Sketchbook Skool, especially those who lent their ideas and art to make this book useful and gorgeous: Miguel Herranz, Jason Das, Penelope Dullaghan, Vin Ganapathy, Cathy Johnson, Tommy Kane, Veronica Lawlor, Michael Nobbs, Salli Swindell, Sabine Wisman and, of course, my Sketchbook Skool co-founder, Koosje Koene.

Jason Bennett, who filmed the kourse this book is based on.

All of the staff at Sketchbook Skool, especially Morgan Green.

My many friends at North Light Books, including David Pyle; Pamela Wissman; my editor, Noel Rivera; and my designer, Clare Finney.

My genius son, Jack, who made lots of kooky exercise diagrams; my late dogs, Joe and Tim; and my producer, advisor and brilliant, lovely wife, JJ Gregory.

And, most of all, to the many tens of thousands of Sketchbook Skool students whose art and passion inspire me every day.

Take a kourse!

This book began as a humble online video kourse at Sketchbook Skool. It took off way beyond my wildest dreams and, soon, zillions of people around the world were signing up: teenagers, retirees, doctors, sanitation workers, even artists who'd lost touch with their drawing skills.

If you'd like me to walk you through the main ideas in this book and demonstrate many of the exercises and concepts, sign up for How To Draw Without Talent the online kourse.

Or, if you already feel empowered by what you've learned in these pages, you could sign up for one of the dozens of other courses we offer on drawing and watercoloring, on drawing buildings and animals and people and roast beef sandwiches and so much more.

Intrigued? Drop by SketchbookSkool.com anytime. No talent required.

Four facts to write on the inside cover of your sketchbook:

1. Never compare yourself to other artists. Don't compare your first drawing to their reproduction in a coffee table book. Let their progress inspire but not intimidate you. Compare you to you. That's all that counts.

2. You're making more progress than you think. You may not see it but it's happening with every page. Guaranteed.

3. Everyone struggles at the beginning. Check out early van Gogh drawings. Awful. Struggle is normal, inevitable, a positive sign that you are working things through. Your early drawings are zero indication of what you will achieve in time. Zero.

4. Remember, you *can* draw. Just keep doing it.